IMAGES
of America

STATEN ISLAND
FERRY

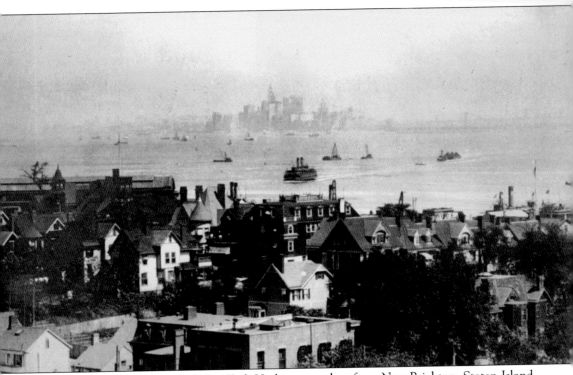

This c. 1925 postcard view of New York Harbor was taken from New Brighton, Staten Island. A Staten Island Ferry is at center, making its way between Manhattan, in the distance, and its sister island across the bay. (Staten Island Museum.)

IMAGES
of America

STATEN ISLAND
FERRY

Staten Island Museum

ARCADIA
PUBLISHING

Published by Arcadia Publishing
Charleston, South Carolina

Printed in the United States of America

Library of Congress Control Number: 2013954625

For all general information, please contact Arcadia Publishing:
Telephone 843-853-2070
Fax 843-853-0044
E-mail sales@arcadiapublishing.com
For customer service and orders:
Toll-Free 1-888-313-2665

Visit us on the Internet at www.arcadiapublishing.com

This book is dedicated to all the community members who keep history alive on Staten Island and to the late Hugh Powell, Dorothy D'Eletto, and Martha Brock, whose combined efforts numbered over 100 years of service in the Staten Island Museum History Archives and Library.

CONTENTS

FOREWORD

To a native New Yorker, the Staten Island Ferry is not unlike the Empire State Building, the Statue of Liberty, Yankee Stadium, or the subway system, for that matter. These iconic points of interest are central to everyday life for many New Yorkers, but they are also must-see destinations for the millions of tourists who visit the city each year.

I was raised in the Bronx, and my first memory of the Staten Island Ferry goes back to when I was around 12 years old. My friends and I took the bus from Throggs Neck to Westchester Square, and we then boarded the No. 6 train to Lower Manhattan. From there, we walked to South Ferry, paid our fares, and took a number of trips back and forth on the Staten Island Ferry before making the journey back to the Bronx. If my mother only knew!

My next memory of the ferry is, of course, high school prom night. It was pretty much tradition for all New York City kids, regardless of their home borough, to end prom night by taking a ride on the Staten Island Ferry. And I was no different. Following high school, I enrolled at the State University of New York Maritime College and graduated with a bachelor's degree and a US Coast Guard license as a third mate. This license allowed me to pursue a career at sea in the maritime industry. Although many of us went to sea on large oceangoing ships, some went to work in New York Harbor on tugboats, barges, sludge boats, and, yes, the Staten Island Ferry. Something I had viewed as a neat place to visit as a kid was actually a part of the industry I had chosen for a career.

During my seagoing career, I worked on oil tankers that often called at the Port of New York, and I ultimately served as master of the training ship *Empire State*. Like clockwork, it entered New York Harbor in early July each year, returning from the annual summer cruise. Each time I sailed through New York Harbor, I would watch through binoculars the orange-colored ferries going back and forth. In addition to the somewhat unusual color, they have a unique design, what we refer to as double-ended, which allows the ferries to operate without having to turn around and thus saves time on the 22-minute crossing. I ultimately realized that the Staten Island Ferries shared a color scheme (blue and orange) with another New York City icon, the New York Mets, and it all made sense. These are the colors of the City of New York!

In early 2004, I was appointed chief operating officer of the Staten Island Ferry and charged with overseeing a complete restructuring of ferry operations and the development and implementation of a safety management system. By this time in my career, I had served in senior management positions in various sectors of the maritime industry, including ferries, so this was a challenge I welcomed.

The Staten Island Ferry operates 365 days per year, 24 hours per day. It is a critical mass-transit link for thousands of commuters going to and coming home from work, shopping, or visiting a doctor. In addition, it is a tourist destination for the millions who visit New York City each year and for the residents of the other boroughs who simply enjoy the ride across the harbor.

I am not really sure there is a typical day, but, at around 4:00 each weekday morning, crews begin arriving at the St. George Terminal and start readying the ferryboats for service. The main engines are carefully warmed up and safety checks are performed throughout the vessels.

Pilothouse control, electronic navigation, collision-avoidance, and communication systems are energized, and all critical equipment is thoroughly tested prior to getting under way. By 8:00 a.m., four large ferries are in service, and rush hour has begun. At the same time, the overnight ferry is being put to bed. The day will include a total of 110 trips back and forth between Staten Island and Manhattan.

During the average workday, the crews will encounter medical emergencies, police action, lost children, passenger injuries, and a variety of other issues. In addition to all of this, the navigation team closely monitors the vessel's movement across the harbor and is in constant communication with all of the other vessels transiting one of the busiest harbors in the world. Docking is always a critical action, and each and every trip is different, largely because of the ever-changing tides and currents and harbor traffic. Down below, the engineers ensure that all ship systems operate as designed, and they stand at the ready to intervene as necessary to make sure that steering and main-propulsion control are available at all times.

There is nothing like a beautiful and clear sunny day on the Staten Island Ferry, and the crews enjoy these days as much as the passengers do. But not all days are like this. The ferries operate in high winds, rain, sleet, snow, and fog. Regardless of all the technology and high-end navigation systems fitted on the ferries, no captain likes operating in reduced visibility or blizzard conditions.

It is during inclement weather like this that the professionalism of the captains and crews is on full display. Passengers embark at St. George, then there is the continuous sounding of the ferry's fog signal. There is nothing to see all the way across the harbor, and then, almost like magic, the Whitehall Ferry Terminal appears, the ferry docks, and the passengers are on their way to work.

For me and my coworkers, there is a tremendous amount of pride in what we do. We take our responsibilities as stewards of this New York City icon seriously and personally. I have had a great career thus far, but as a native New Yorker, the capstone has surely been the honor of overseeing the nation's oldest and largest passenger ferry system, the Staten Island Ferry.

The following pictorial of 108 years of ferry service represents the heritage of New York City and is both powerful and enduring. Thank you for riding the Staten Island Ferry!

—Capt. James C. DeSimone

ACKNOWLEDGMENTS

The Staten Island Museum would like to thank the dedicated people who made this book possible.

Thanks go to Susan Miller, editor; Tamara Coombs, contributor; Capt. James C. DeSimone, contributor; and Patricia Salmon, former curator of history, Staten Island Museum.

Special recognition goes to the Staten Island Museum staff: Cara Dellatte, archivist, writer, and researcher; Christopher Elford, collections intern; Diane Matyas, vice president of programs and exhibitions; and Shawn Vale, photography editor.

All photographs are from the Staten Island Museum unless otherwise indicated.

An American Icon

We were very tired, we were very merry—
We had gone back and forth all night on the ferry. . . .
And you ate an apple, and I ate a pear,
From a dozen of each we had bought somewhere;
And the sky went wan, and the wind came cold,
And the sun rose dripping, a bucketful of gold.

—Edna St. Vincent Millay, "Recuerdo"

The Staten Island Ferry is more than transportation. It is a tourist attraction, a floating public space, and a great history lesson about New York City's growth, activity, and the people who live here. Interest in the ferry—and its history—never seems to wane. Fascinated travelers and ferry buffs from all over the world are drawn to its endlessly operating gangplanks. This book of vintage photographs and background information, culled primarily from the Staten Island Museum's archive, has been created to satisfy this constant interest.

Constantly crisscrossing between Lower Manhattan and Staten Island—to an outsider, the repetition might seem like a tedious trek, but to seasoned crew and riders, no 5.2 mile, 25-minute voyage is exactly the same. The sky, the weather, the sites, and the maritime activity of tugboats, barges, cruise ships, Coast Guard, and huge container ships are always in flux. Similarly, the riders and crew, with distinct habits and reasons for making the journey, add to the experience. Morning coffee groups arise and Friday night dates watch the city lights recede or rise up on their way. And because those who work on the boat bid for their jobs, they spend years with the same coworkers—and the same commuters. In the past, roving vendors were also part of the mix. The boat holds a society, a floating world.

If the Statue of Liberty is the star of New York Harbor, the ferry is its live theater. More than two million tourists take the ferry every year to view the scenic attractions of one of the world's greatest harbors. For them, the focus is mostly on the experience of the ride—especially what can be seen from the boat. After all, the best camera shot of the Statue of Liberty is not from Liberty Island, but from the deck of a Staten Island Ferry.

The chapters of this pictorial book cover "Early Ferries"; their "Destinations"—when Brooklyn to Staten Island routes were popular (long before the Verrazano-Narrows Bridge was built); the "City Takes Over," describing how municipal ferries were built and regulated service took the helm of water transportation to New York State's southernmost county; the ever-changing "Whitehall Terminal" and "St. George Terminal"; the different "Ferry Classes through the Years"; people "Onboard the Ferry"; and "Weather," the leveler of all maritime safety concerns.

The Staten Island Museum hopes you will enjoy this historic look at the ferry that has come to signify the city of New York in so many ways. The next time you step off the boat, visit our St. George and Snug Harbor Cultural Center sites to learn more about the art, history, and science of New York's best-kept secret, Staten Island!

One

EARLY FERRIES

The original inhabitants of Staten Island, the Lenape, were a part of the great Delaware, or Algonquin, Nation. Those who inhabited what would become Staten Island and those who visited it used wooden or dugout canoes created by burning and gouging out the centers of large trees.

In the 18th century, sailboat ferries were used between Manhattan and Staten Island, where passengers could embark at the Watering Place (Tompkinsville) and at Tottenville. When winds were weak, it could take upwards of two or three hours to travel across the harbor. Due to the alliance that Staten Island had with the British during the Revolutionary War, many of the ferry landings were blocked. Eventually, islanders were allowed to use both Cole's Ferry and Decker's Ferry.

In the 19th century, Staten Island was an important location for those who traveled between Albany, Boston, New York (Manhattan), Philadelphia, Baltimore, and Washington, DC, because the ferries stopped at Staten Island to pick up or disembark passengers.

In the 19th century, steam ferryboats were wooden paddle steamers with side wheels driven by a beam engine. The first official steam ferry was the *Juliana*. It ran from Vesey Street in Manhattan to Hoboken, New Jersey, under the supervision of Col. John Stevens in 1811.

Railroad and steamship magnate George Law was on the board of directors of the New York & Staten Island Steam Ferry Company. By sales of ownership and through lawsuits, the company evolved into a ferry that ran from the Whitehall Slip in Manhattan.

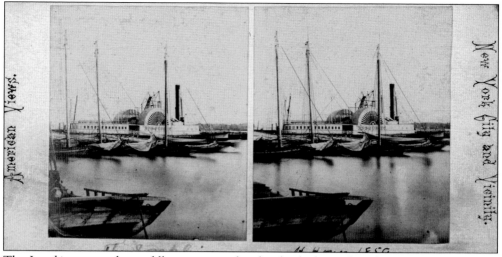

The *Josephine*, a wooden paddle steamer with side wheels driven by a beam engine, was built in 1852 by the New York & Staten Island Steam Ferry Company. It ran between the east shore of Staten Island and Whitehall Terminal in Manhattan. Other boats sailing for this company included the *Southfield*, *Westfield*, *Clifton*, and *Northfield*. Unlike today's boats, they were all single-ended. This 1859 stereoscopic view of the *Josephine* is by H. Hoyer.

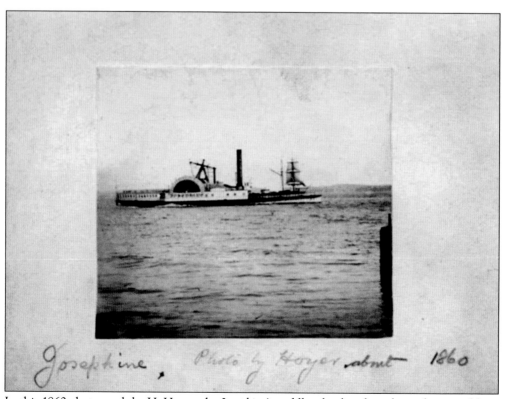

In this 1860 photograph by H. Hoyer, the *Josephine*'s paddle wheel and smokestack are visible.

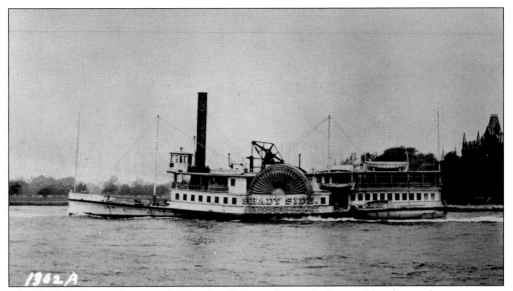

The *Shady Side* was photographed in the 1860s in front of a Staten Island waterfront mansion. The North Shore Line, taken over by John H. Starin in 1877, became the New York & Staten Island Steamboat Company, which ran until 1884. The *Shady Side* and *Black Bird* were among nine ships making up Starin's fleet.

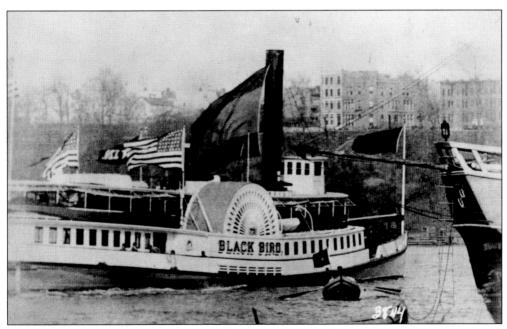

A sense of the size of the *Black Bird* is suggested by the rowboat nearby in this c. 1864 photograph.

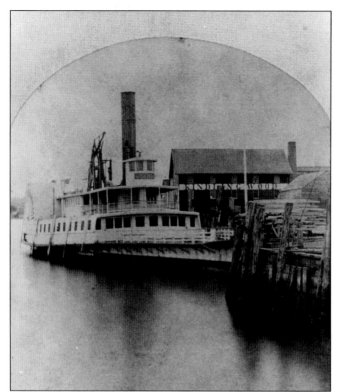

A ferryboat docks at the North Shore landing at the end of Richmond and Port Richmond Avenues. The sign on the building reads "Kindling Wood." The boat may be the *Flora*, which was known for its speed. Sold for $18,000 in 1862 to the Union, it was refitted to carry dispatches in the area of Beaufort, South Carolina. Its shallow bottom made for easy maneuvering in the low waters of the South, and the sturdy decks were well suited for heavy guns. Travelers took the *Flora* and the *Pomona* to Pier 18 on the North River (Hudson River) from Elm Park, Port Richmond, Snug Harbor, and other points.

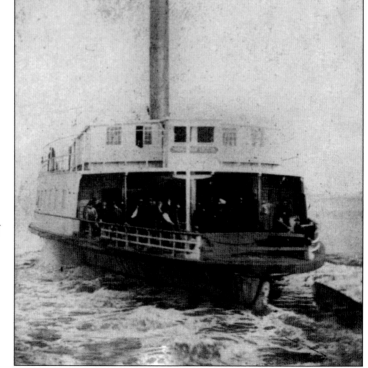

The *Southfield* was one of several boats that went into service on behalf of the Union during the Civil War. On April 19, 1864, the ship was struck by the *Albemarle*, a Confederate ironclad, and sank. H. Hoyer took this photograph in 1859.

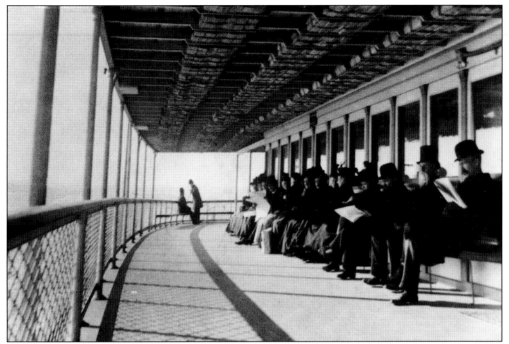

On November 19, 1890, Staten Islander Alice Austen, one of the earliest and most acclaimed American female photographers, captured these passengers on the outside deck of the *Northfield*. Notice that everyone is wearing a hat. In the 19th century, top hats were a staple of upper-class men's formal wear; stiff bowlers and soft felt hats in a variety of shapes were worn for more casual occasions.

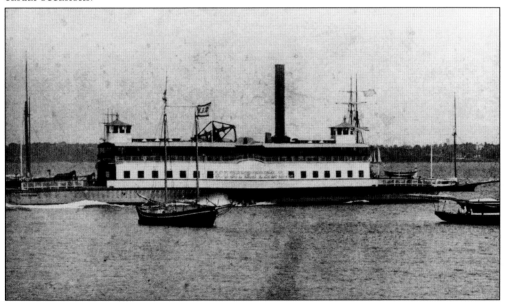

Built in 1863 as a paddleboat with a wooden hull, the *Northfield* sank off the Battery on Flag Day (June 14) in 1901. It collided with the *Mauch Chunk*, a Central Railroad of New Jersey ferryboat. In 1904, the *Northfield* was raised and broken up, and the remains were sold to a salvager for $25.45.

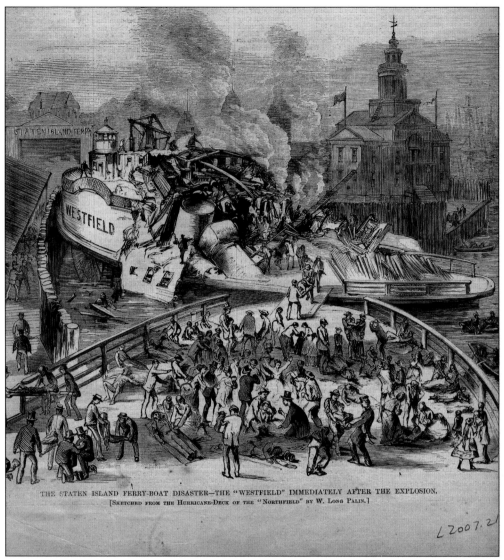

THE STATEN ISLAND FERRY-BOAT DISASTER—THE "WESTFIELD" IMMEDIATELY AFTER THE EXPLOSION.
[Sketched from the Hurricane-Deck of the "Northfield" by W. Long Palin.]

On July 30, 1871, a boiler explosion occurred on the *Westfield*. Approximately 200 people were seriously injured. The number of fatalities was reported at the time as exceeding 40, perhaps as many as 100. Subsequent statements claimed that as many as 66 individuals were killed. Even though the ferryboat sustained a great deal of damage, it was rebuilt and used for many more years. This sketch, produced by W. Long Palin from the hurricane deck, appears in the August 12, 1871, *Harper's Weekly*.

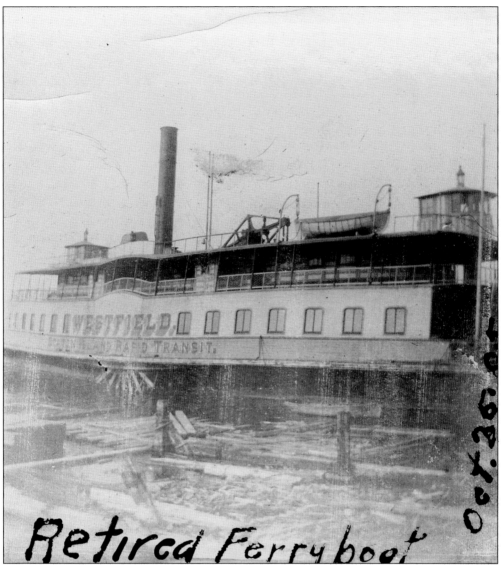

This is the rebuilt *Westfield*, which went out of documentation in 1912 and was the last *Westfield* to traverse New York Harbor. The first ship to carry this name was sent to war in February 1862 and was blown up by its commander to keep it out of rebel hands. The second ship was blown to bits in a boiler explosion on July 30, 1871, and was later rebuilt. Many years later, Capt. Johnny Hammel spoke about sailing on the rebuilt ship: "I sailed on that *Westfield* many, many times, but I never did care for her greatly. A death boat has a dislikeable feeling. It gave me a fearsome uneasiness, a chill of the spirit."

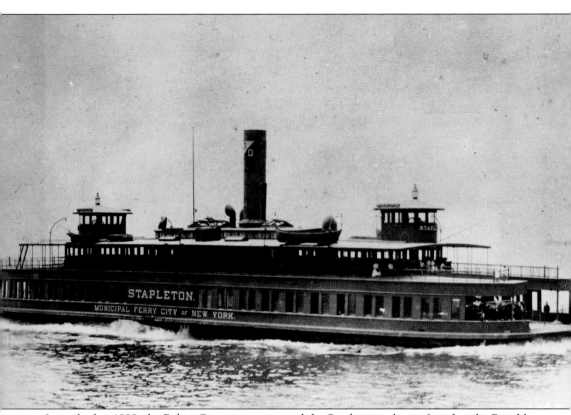

Launched in 1888, the *Robert Garrett* was renamed the *Stapleton* and transferred to the Brooklyn run when New York City took over ferry service in 1905. The *Stapleton* was converted to a barge in 1940 and dismantled in 1956.

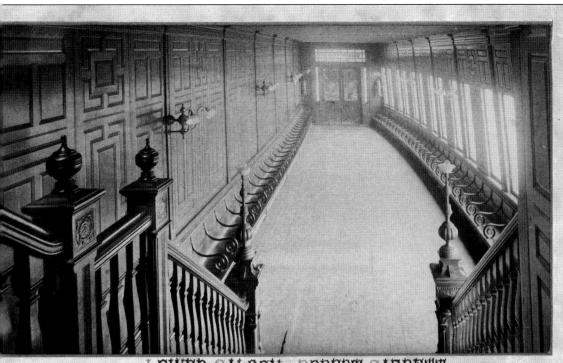

LOWER SALOON – ROBERT GARRETT.

The lower saloon of the *Robert Garrett* boasted elegant wood paneling and an ornate staircase. Such attention to detail was common on early ferryboats, whose interiors were designed to make a passenger's journey as pleasurable and relaxing as possible.

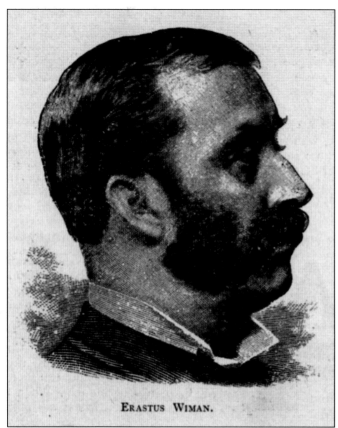

ERASTUS WIMAN.

Erastus Wiman was born in Churchville, Upper Canada (now Ontario), in 1834 and arrived in New York City to run a local branch of R.G. Dun & Company. Attracted to Staten Island by its open spaces, which allowed the pursuit of outdoor activities, he grew to love the island. His efforts to advance train and ferry services were assisted by the president of the Baltimore & Ohio Railroad, Robert Garrett.

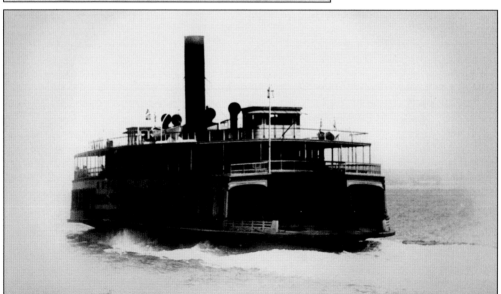

The *Erastus Wiman* ferryboat, like the *Robert Garrett,* had a hull made of steel instead of iron. Launched from the Columbian Iron Works in Baltimore on April 26, 1888, the ferry cost $185,000 and carried up to 3,000 passengers. When the city took over service in 1905, she was renamed the *Castleton* and was transferred to the Brooklyn run. In 1918, the *Castleton* was destroyed by fire.

Two

DESTINATIONS

March 25, 1880, was a very important date in the history of Staten Island. That day, a meeting was held to discuss the idea of a single ferry serving both the east and north shores of Staten Island. As a result of this meeting, the Staten Island Rapid Transit Railroad Company was organized. In 1886, the company's ferry fleet consisted of the *Westfield*, *Northfield*, *Middletown*, and *Southfield*. The steel-hulled *Robert Garrett* and *Erastus Wiman* were soon added. It was Erastus Wiman who is responsible for establishing the Staten Island Ferry as it is known today. While other ferries went to Whitehall, none departed from or arrived at St. George, as there was no St. George until Wiman developed it.

The route between Whitehall and St. George was not the only option for people who wanted to travel by ferry. There were also two ferry lines between St. George and Brooklyn. The ferry that ran between Thirty-ninth Street, Brooklyn, and St. George became a municipal operation in 1906. On June 4, 1924, the *New York Bay Ferry* began sailing on this route. On July 4, 1924, the Brooklyn & Richmond Ferry Company started service between St. George and Sixth-ninth Street, Brooklyn. In 1939, a company called Electric Ferries began operating that ferry line.

Both ferry lines between Staten Island from Brooklyn ceased operations in the middle of 20th century. The first to go was the Thirty-ninth Street ferry. On June 25, 1946, when the St. George Ferry Terminal burned down in a devastating fire, ferries that ran to Whitehall could not use their usual slips. Those ferries took over the slip of the Thirty-ninth Street Ferry, thus ending that route. Ferry service from Sixty-ninth Street, Brooklyn, ended when Staten Island and Brooklyn were connected by the Verrazano-Narrows Bridge, which opened on November 21, 1964.

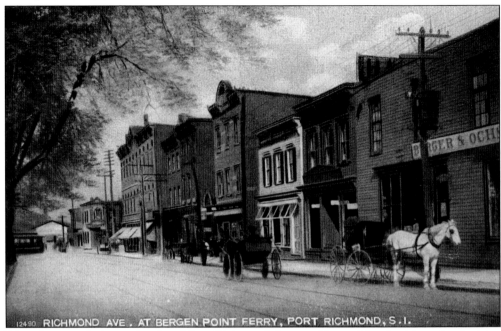

RICHMOND AVE. AT BERGEN POINT FERRY, PORT RICHMOND, S.I.

This photograph shows shop-lined Port Richmond Avenue, Staten Island, with a view looking towards the terminal of the ferry to the Bergen Point (now Bayonne, New Jersey) ferry (lower left). Port Richmond Avenue remains a busy street on Staten Island.

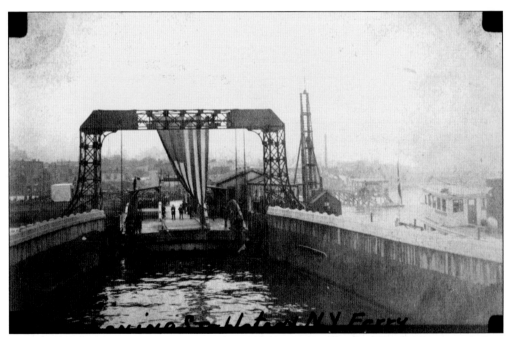

All the fanfare that the City of New York could muster for a Staten Island event occurred on May 27, 1909, when ferry service from Whitehall to Stapleton was inaugurated. At the event, 1,000 schoolchildren sang "The Star-Spangled Banner," and borough presidents, the mayor, and the docks commissioner were in attendance.

Ferry service operated between Staten Island and New Jersey from a number of locations. In the 1920s, this dilapidated car ferry was still running between Staten Island and Elizabethport, also known as Holland Hook.

The *Maid of Perth*, built in 1867, was considered the first real ferryboat between Staten Island and Perth Amboy. Service between these two locations was established in June 1860. The ferryboat was eventually sold to Albany Interests and moved to Albany. It was abandoned soon after and disintegrated on the rocks in 1905.

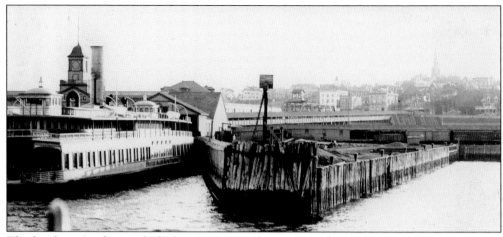

The ferryboat *Castleton* is docked in St. George Slip in 1906. The clock tower of the new Carrère & Hastings ferry terminal can be seen at left. The newly formed town of St. George, named after illustrious businessman George Law, occupies the hillside in the distance.

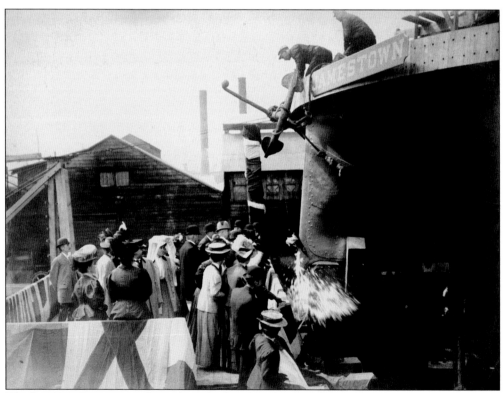

The ferryboat *Jamestown* is being launched in this photograph. Note the breaking of a bottle of champagne on the hull, the traditional way to christen a new boat. The *Jamestown* was built for the Erie Ferry Railroad Company in 1907 by the Burlee Dry Dock Company in Port Richmond, Staten Island. Shipbuilding remained a major industry on Staten Island until the end of World War II.

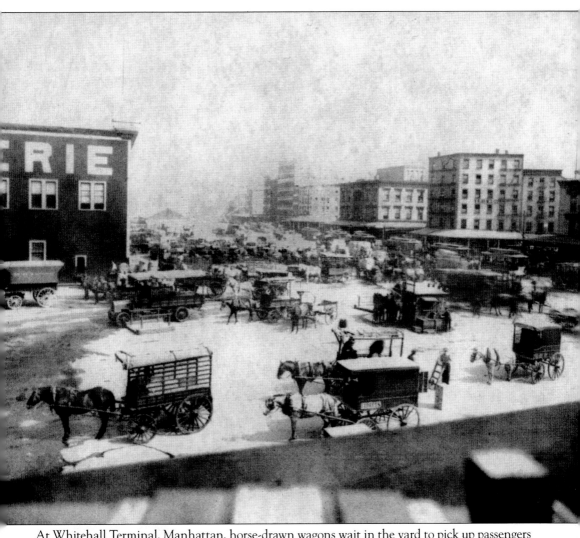

At Whitehall Terminal, Manhattan, horse-drawn wagons wait in the yard to pick up passengers as they disembark from the ferry.

The Sixty-ninth Street Ferry operated between Sixty-ninth Street in Bay Ridge, Brooklyn, and Fort George. In this 1933 photograph, the *Astoria* is at center, and the *Whitehall* is at left.

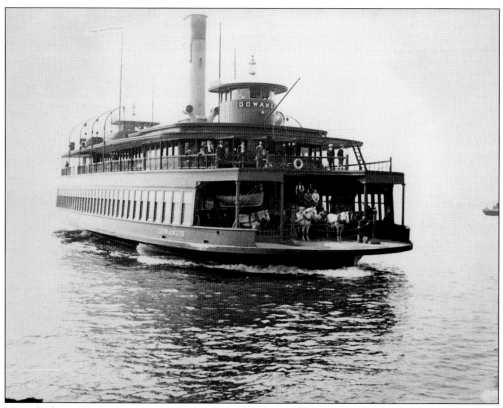

Note the horse-drawn carriages on the lower deck of the ferryboat *Gowanus* in this 1907 photograph. White horses with carriages can be seen on the lower deck, and their drivers and passengers pose for the photograph. This ferryboat would later go aground on the lower end of Governors Island in Buttermilk Channel.

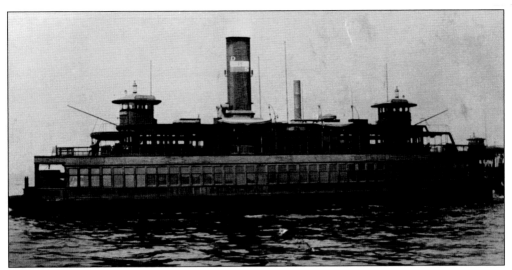

This is the *Bay Ridge* in 1919 en route between Sixty-ninth Street in Brooklyn and St. George, Staten Island. The ferries operating between Brooklyn and Staten Island ran from a location just south of where the current Staten Island Ferry Terminal stands. Before the opening of the Verrazano-Narrows Bridge, cars and their passengers waited in long, sweltering lines to board boats on Sunday evenings in summertime.

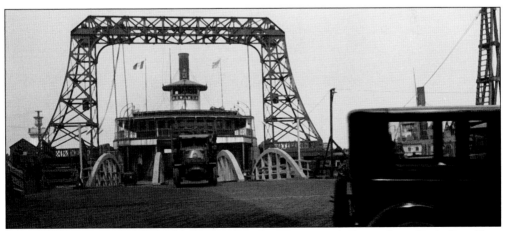

Cars are being unloaded from the *Gowanus* at the Thirty-ninth Street ferry slip in Brooklyn. The Thirty-ninth Street Ferry, running between Brooklyn and St. George, became a municipal operation in 1906. Ferry service between Staten Island and Thirty-ninth Street in Brooklyn ceased on June 25, 1946, after the St. George Ferry Terminal burned down in a devastating fire.

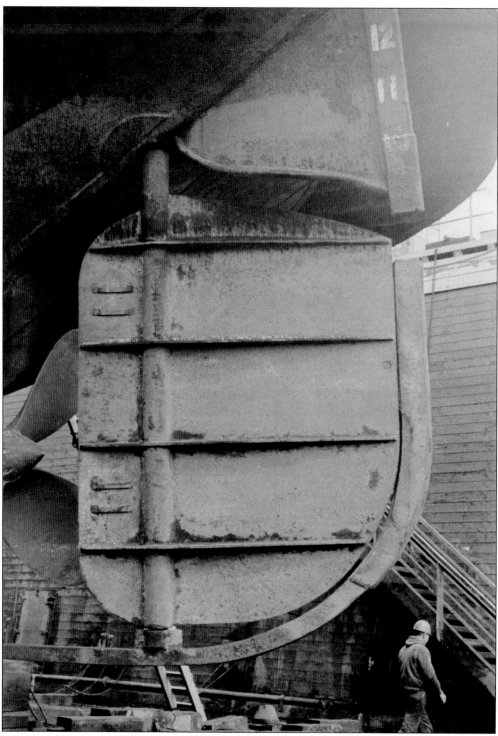

The *Hamilton, Gotham, Narrows, Tides, E.G. Diefenbach, Hudson,* and *St. George* operated on the Brooklyn line. These boats were much smaller than those running between St. George and Whitehall. Here, men repair the rudder of the *Hamilton*.

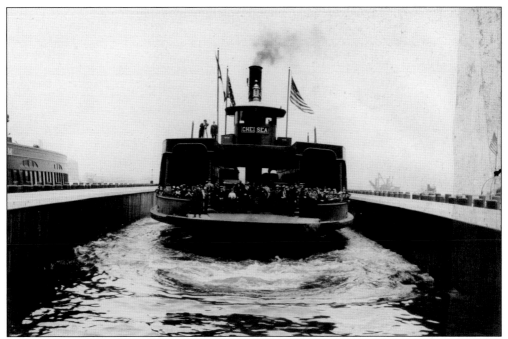

The ferryboat *Chelsea* is seen here in 1930. Cars can be seen directly behind the crowd, and a photographer stands on the upper deck next to the wheelhouse.

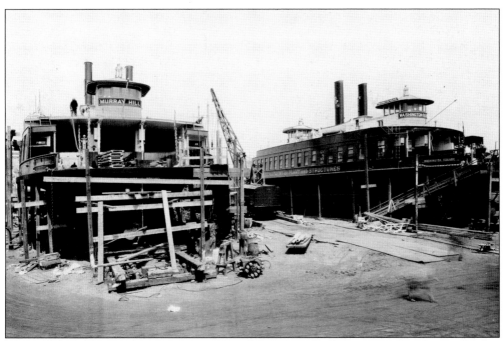

The *Murray Hill* (left) and *Washington Square* ferryboats, seen here in a shipyard, were the last two ferryboats of the East River Municipal Ferry lines. The *Murray Hill* was eventually used for service to Governors Island and had the distinction of ferrying Pres. Franklin Delano Roosevelt to that island. (John Landers Collection.)

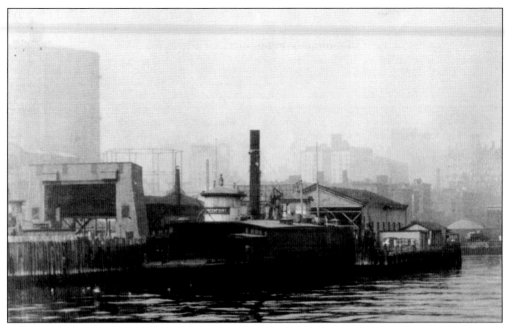

The ferryboat *Greenpoint*, built in 1898, had a long career. Used on the Delaware River until New York City purchased it in 1921, the *Greenpoint* was scrapped in 1941. (John Landers Collection.)

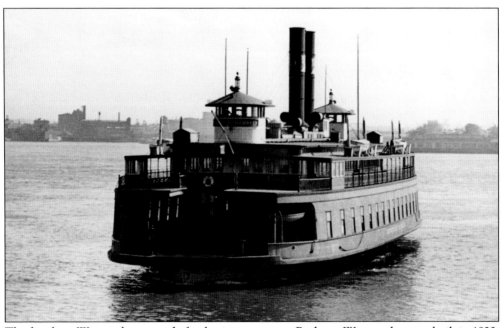

The ferryboat *Wanamaker*, named after business magnate Rodman Wanamaker, was built in 1923. It was mainly used for service from Brooklyn to Staten Island. In 1909, Wanamaker came up with the idea of constructing a monument to Native Americans, and he went on to develop a plan to create a statue of a Native American, similar in size to the Statue of Liberty, that would stand on Staten Island. He sponsored the 1913 ground breaking on the island, but the monument to the First Americans was never built. (John Landers Collection.)

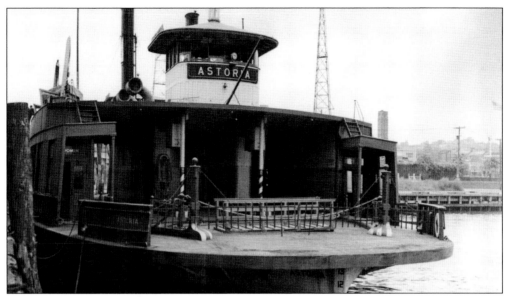

The *Astoria* is seen here empty at a terminal. The boat appears to be temporarily out of service or awaiting repair. The hull of the ferryboat can be found in the water at the ship boneyard off the shores of Staten Island. (John Landers Collection.)

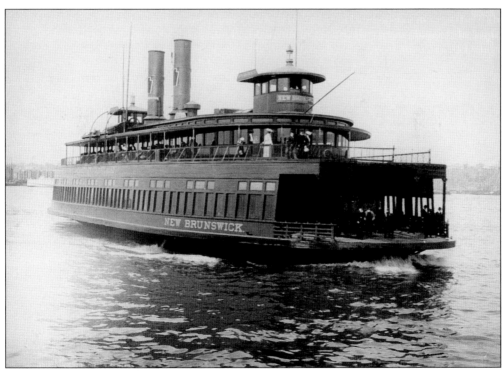

Ferries ran between Staten Island and the New Jersey towns of New Brunswick, Perth Amboy, and Keyport starting in the 1860s. Here is the *New Brunswick* on its route around 1907.

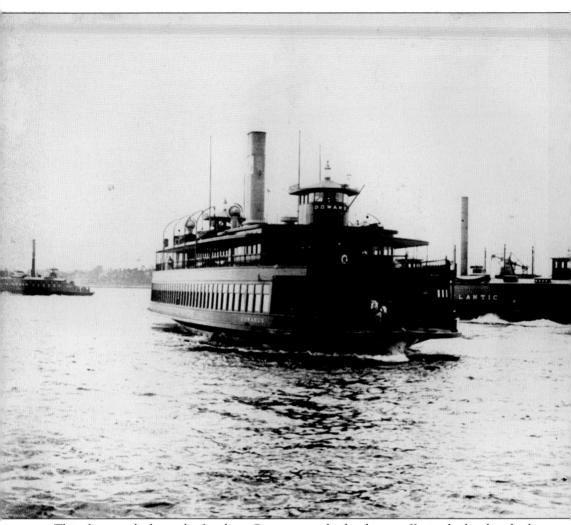

This photograph shows the ferryboat *Gowanus* amid other boat traffic in the bustling harbor. The ferry on the far right is the *Atlantic*; the one on the left is the *Mineola*.

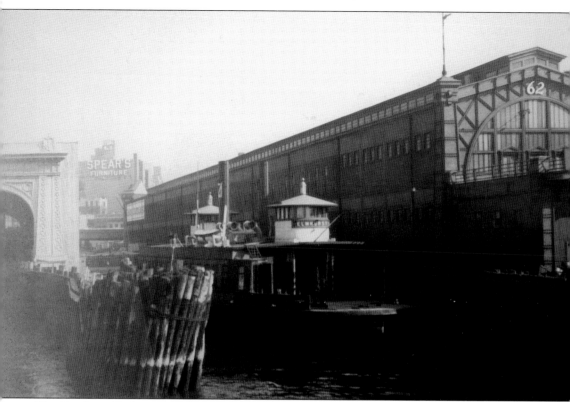

The ferryboat *Elmhurst*, seen here at Pier 62 in Manhattan, was, like many ferryboats from this era, named after a neighborhood in one of New York City's five boroughs—in this case, Elmhurst, Queens. This boat, built in 1925 and taken out of service in 1963, was originally part of the East River Ferry line. (John Landers Collection.)

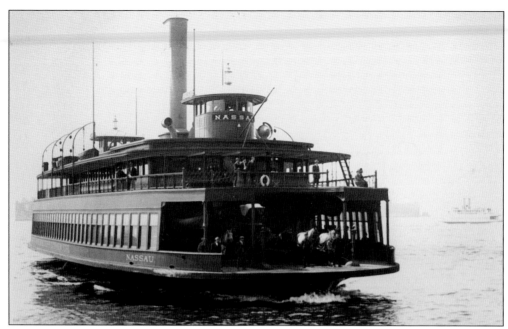

The ferryboat *Nassau* moves across New York Harbor in September 1907, when the main mode of land transportation was still the horse-drawn carriage.

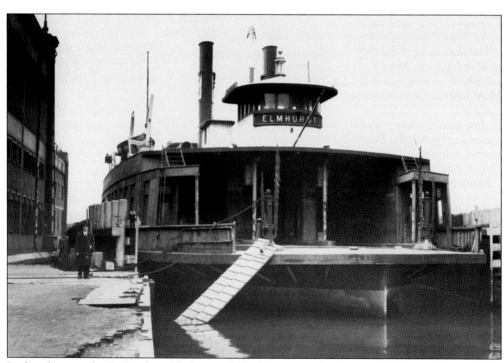

In this photograph, the ferryboat *Elmhurst* is docked at Pier 62, in the Chelsea section of Manhattan. From 1910 to the middle of the 20th century, the Chelsea Piers were New York's premier passenger-ship terminal. In the mid-1990s, Chelsea Piers was reborn as an enormous sporting facility. (John Landers Collection.)

Three

CITY TAKES OVER

The decision by the City of New York to take over the ferry service had a great deal of support. The first borough president of Staten Island, George Cromwell, announced bids for new ferryboats on June 10, 1904. Each of the first five of these new municipal ferryboats was named after one of New York's City's five boroughs—the *Richmond*, *Bronx*, *Manhattan*, *Brooklyn*, and *Queens*. (The Borough of Richmond was renamed the Borough of Staten Island in 1975.) Together, they became known as the Borough class of vessels.

The launching of the *Bronx*, *Brooklyn*, *Queens*, and *Manhattan* at the Sparrow's Point shipyard in Maryland was a bit of a fiasco. On April 8, 1905, the four shiny, new ferryboats sat ready for launch. Workmen began the process of sawing and hammering the wooden shore holding the *Manhattan* in order to release it into the water. Shortly after the *Manhattan* was safely afloat, the workers tried to release the *Bronx*, but the boat refused to move. Those waiting for the ferryboat to drop into the water watched with bated breath as the boat refused to move. Those in charge decided to launch the *Brooklyn*, but it would not move, either. Then, 20 minutes later, the *Bronx* moved, but only to the water's edge. The *Queens*, in line behind the *Bronx*, also missed the launch date.

Municipal service commenced on the morning of October 25, 1905, when the *Manhattan* set sail, amid much fanfare, from Whitehall Terminal. As it glided past the Statue of Liberty, its sister ships—the *Brooklyn*, *Queens*, and *Bronx*—joined the *Manhattan* in a grand procession across the harbor. As the *Manhattan* took off on its maiden voyage from Whitehall, the *Richmond* departed, appropriately enough, from the St. George Terminal in Staten Island.

The new ferries were described as "stiff," not an unusual description for a new ferryboat. The *Richmond* would actually lose its steering during that first night of operation. Departing from Staten Island at 7:15 p.m., it did not arrive in Manhattan until 8:35 p.m.

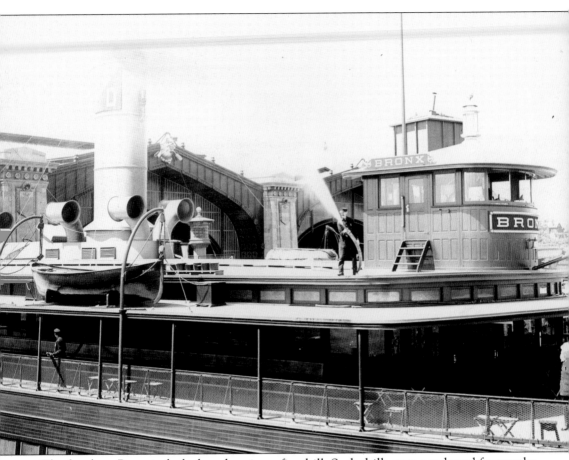

The ferryboat *Bronx* is docked, undergoing a fire drill. Such drills were conducted frequently; it was of the utmost importance that, in case of an actual fire, proper procedures would be followed flawlessly.

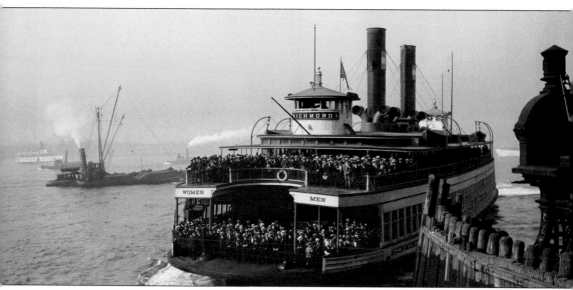

Passengers wait to disembark from the *Richmond* as it enters Whitehall Terminal. This photograph was taken in 1921, most likely in summer, since the men are wearing straw hats, the style appropriate for warm weather. Men and women could chose to segregate themselves in designated areas on the lower deck. Smoking was permitted in the men's cabins, but was not allowed for women.

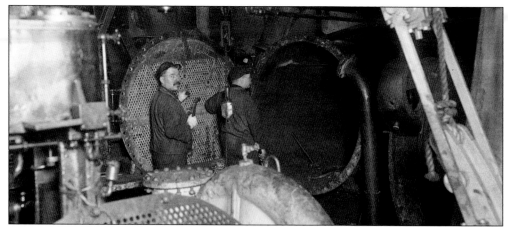

Machinists work in the engine room of one of the Borough-class ferryboats. This 1919 photograph, showing the boat's condenser with its tube sheets removed, is from the collection of the New York Department of Plant and Structures, a precursor to today's New York Department of Transportation. The majority of the Plant and Structures photographs capture men at work on the ferries, including, as here, inside the belly of the boat.

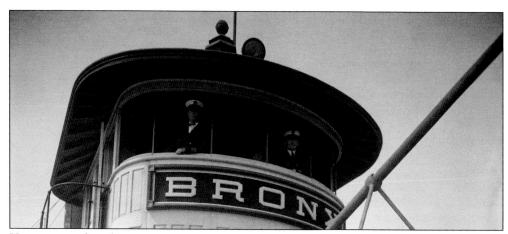

Here, in another documentary image from the New York City Department of Plant and Structures, two ferryboat captains pose for a photograph as they guide the *Bronx* safely across New York Harbor.

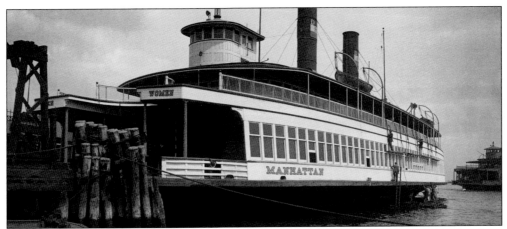

The *Manhattan* is tied up for painting in St. George Terminal in 1920. The *Manhattan* ferryboat is part of the Borough class, established in 1905 and made up of the *Manhattan, Bronx, Queens, Brooklyn,* and *Richmond.*

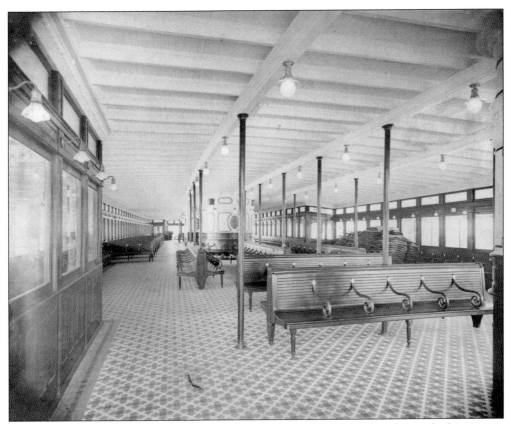

This shot of the saloon deck of the *Bronx* features its graceful wooden benches and other aspects of its interior décor. On April 27, 1928, the *Bronx,* heading into Staten Island in a rainstorm with 2,000 aboard, suddenly took a dive to starboard, inundating the lower cabin on that side with five feet of water. Five passengers were swept overboard, three of whom drowned. This tragedy became known as "The Bronx Disaster."

In the c. 1933 photograph above, the *Queens* is preparing for boarding. Below is a c. 1920 image of the interior of the upper saloon deck of the *Queens*. During World War II, the ferryboat, which had been out of service, was reactivated as a relief boat for the Staten Island Ferry. It was scrapped in 1947.

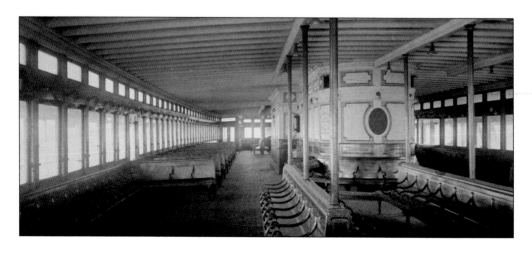

The Borough class was designed to improve travel conditions and accommodations for ferry passengers. This 1919 photograph affords a look into the women's restroom. Note the high level of detail and finish typical of the era, including the tufted upholstery at lower right.

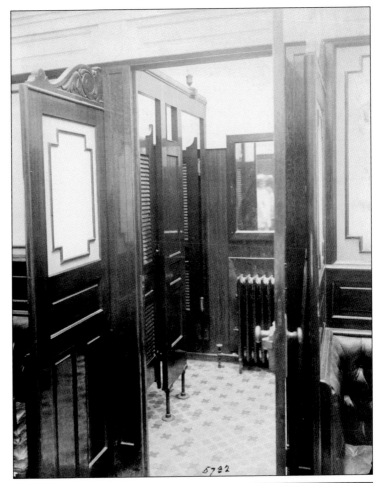

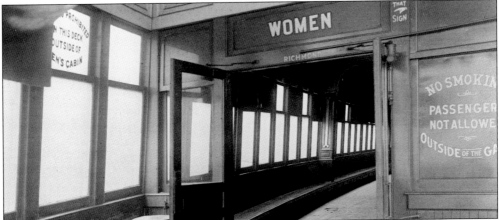

Prior to the 1905 municipal takeover of the Staten Island Ferry, conditions on board were often harsh, with passengers not separated from horses, for example, and other inconveniences, including poor restroom facilities. In the Borough-class ferryboats, women's restrooms were located on the other side of the boat from the men's facilities and were well appointed and clearly marked, as can be seen in this 1920 photograph taken inside the *Richmond*.

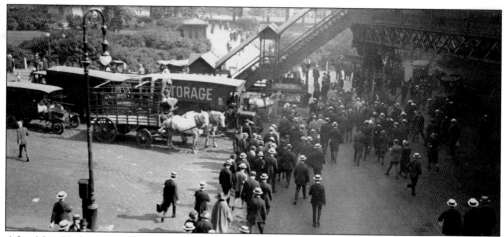

After New York City took over operations of the Staten Island Ferry, ridership soared. Crowds of male passengers head for the Staten Island Ferry at Whitehall Terminal around 1921. Note the straw hats, de rigueur in summertime.

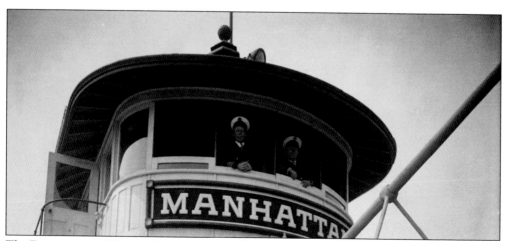

The Department of Plant and Structures carefully documented those who worked on the Staten Island ferryboats, including their captains. Preserved in glass negatives, these images help history come alive.

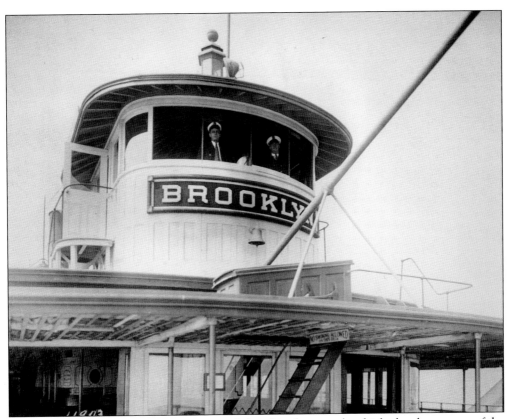

The *Brooklyn* and its two captains are recorded in this photograph, which also shows some of the intricate woodwork that distinguished the Borough-class vessels.

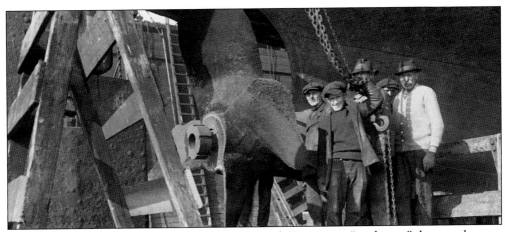

The *Richmond* sits in dry dock, waiting to be serviced. Known as a "yard gang," these workers are changing the propeller on the ferryboat.

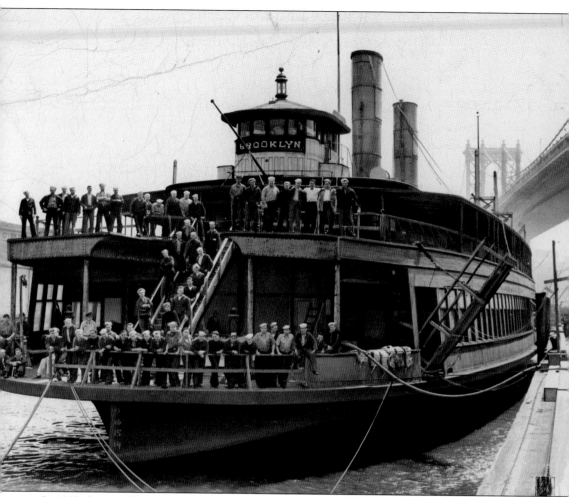

In 1937, the *Brooklyn* became a mechanical arts workshop, moored first at McWilliams' Shipyard, Staten Island, and later at Peck Slip in Manhattan. During World War II, merchant seamen were said to have trained aboard the decks of this ferryboat. The *Brooklyn*, like the *Queens*, was scrapped in 1947.

Four

WHITEHALL TERMINAL

The debate over where to put the Staten Island Ferry terminal at Whitehall lasted almost a year. Between 1902 and 1903, there was much discussion regarding the best location. The terminal was built at the site of today's terminal, but on July 2, 1919, at the South Ferry's elevated railroad, a fire erupted, burning away most of the wooden buildings on the elevated structure. The fire damaged the front of the Staten Island Ferry Terminal building. For a now unknown reason, 60 sailors were confined to sickbeds on the second floor of this terminal. Various firemen, Coast Guard personnel, and police officers assisted with their evacuation. A ferryboat from Staten Island had just disembarked passengers at the terminal, and they were forced back by the fast-growing fire that was fanned by a breeze as it licked its way toward them. Downtown firemen responded, and a number of fireboats made battle lines on both sides of the stricken area.

Today, as passengers depart the Whitehall Terminal aboard the Staten Island Ferry, they can see, toward the East River, a green Victorian ferry terminal that is used for the ferries that glide over to Governors Island. At one time, a twin of this building served Staten Island Ferry riders. In early 1953, the Marine and Aviation Department announced a $3 million renovation project for the once fabulous Whitehall Terminal. The new terminal was to be an architectural marvel. It opened on July 24, 1956.

Another fire ripped through Whitehall Terminal on Sunday, September 8, 1991. In all, 40 firefighting units and 200 firefighters attacked the blaze from the ground, the water, and the air. This fire devastated Whitehall, forcing it to shut down and undergo extensive repairs. After an investigation, the fire was blamed on homeless persons living in the ferry terminal during the frigid months. An interim waiting room was opened in December 1992, until construction could be completed on a new Whitehall Terminal.

The refurbished Manhattan terminal saw a ribbon-cutting ceremony on February 8, 2005. As part of the New York City Percent for Art program, 28 granite benches designed by Ming Fay were installed. His seating project, called *Whitehall Crossing*, represents the Native American canoes that once crossed New York Bay.

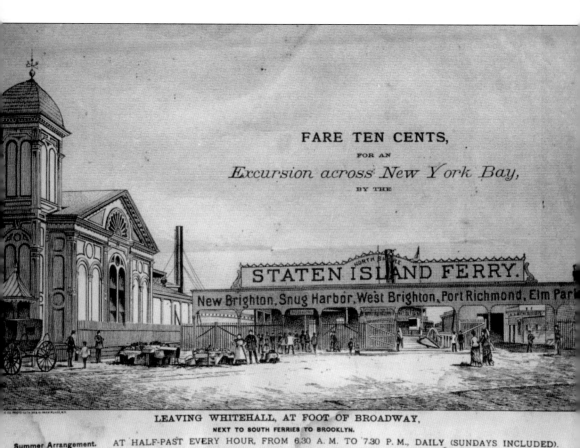

FARE TEN CENTS,

FOR AN

Excursion across New York Bay,

BY THE

STATEN ISLAND FERRY.

New Brighton, Snug Harbor, West Brighton, Port Richmond, Elm Park

LEAVING WHITEHALL, AT FOOT OF BROADWAY,

NEXT TO SOUTH FERRIES TO BROOKLYN.

Summer Arrangement. AT HALF-PAST EVERY HOUR, FROM 6.30 A. M. TO 7.30 P. M., DAILY (SUNDAYS INCLUDED).

Trip to Last Landing (Elm Park), opposite to Newark Bay—10 miles; Time—1 hour; stopping at all the above Landings. FARE, Ten Cents.

RETURNING, LEAVE THE ISLAND HOURLY.

This reproduction of a 100-year-old lithograph shows Whitehall Terminal and its entrance in 1862. The terminal is located at the bottom of Broadway. An "excursion across New York Bay" cost 10¢. Ferries departed every hour on the half-hour between 6:30 a.m. and 7:30 p.m. daily. From Staten Island, departures were scheduled on the hour from New Brighton, Snug Harbor, West Brighton, Port Richmond, and Elm Park.

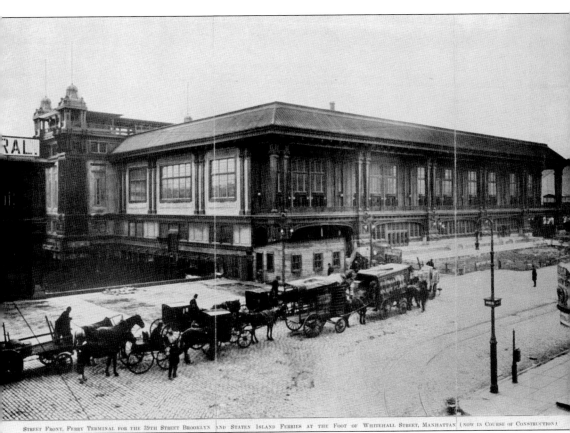

STREET FRONT, FERRY TERMINAL FOR THE 39TH STREET BROOKLYN AND STATEN ISLAND FERRIES AT THE FOOT OF WHITEHALL STREET, MANHATTAN (NOW IN COURSE OF CONSTRUCTION)

The old Whitehall Terminal, pictured here, bears little or no resemblance to today's terminal. Ferries ran from here to Thirty-ninth Street, Brooklyn, and to Staten Island. Horse-drawn carriages line up to pick up passengers as they exited the terminal.

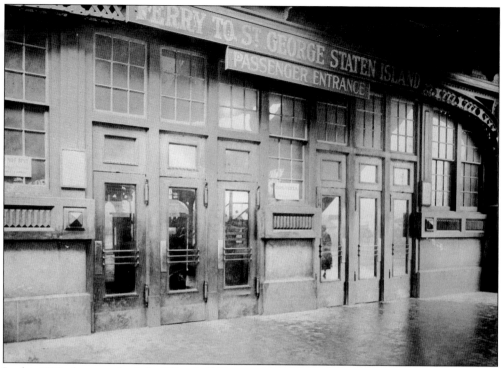

In this 1920 photograph of the Whitehall Terminal, banks of individual doors line the entrance. It is interesting to note that the entrance to today's terminal retains this design feature, though in much updated form.

The Whitehall Ferry Terminal is seen in the center background, with the skyline of Manhattan towering above it. The ferryboat passing on the left has just left Whitehall and is heading toward the terminal in Staten Island. This photograph was taken by Eliza Lake in July 1933.

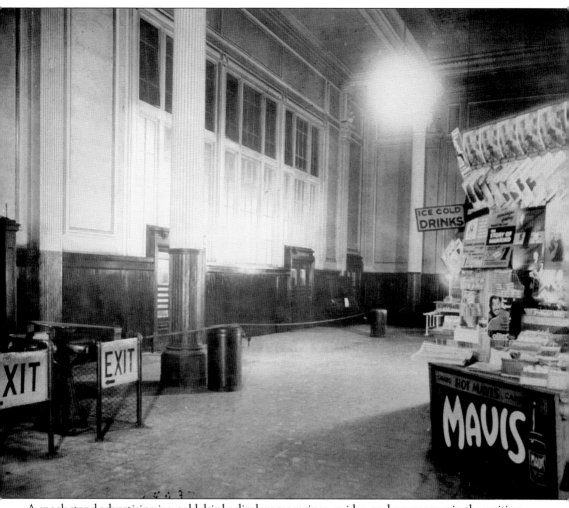

A snack stand advertising ice-cold drinks displays magazines, guides, and newspapers in the waiting room of the Whitehall Ferry Terminal. Joseph Sheldifer took this photograph on April 2, 1931.

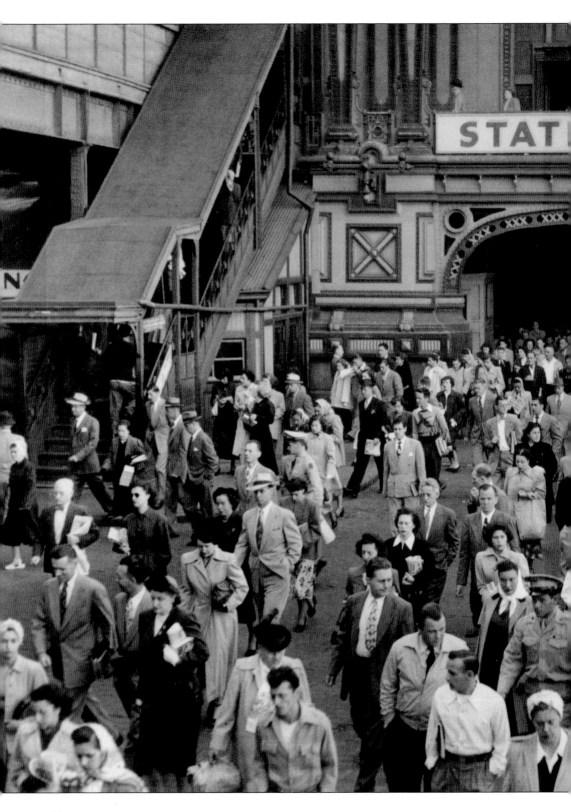

Anthony Lanza was an important newspaper photographer during the early and middle years of the 20th century and took a series of memorable pictures of the Staten Island Ferry and its commuters. His 1949 photograph of commuters exiting the Whitehall Terminal captures the morning bustle at the terminal. Cars, visible in the background, could not leave the boat until all passengers had departed. (Anthony Lanza Collection.)

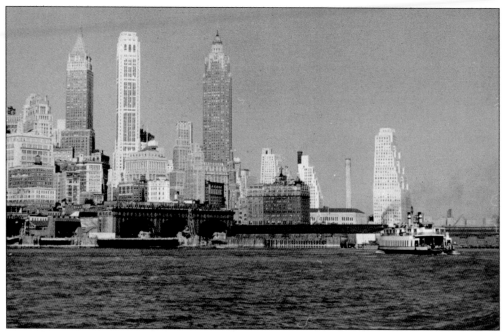

Whitehall Terminal is seen here from a distance, backed by some of the most iconic skyscrapers in Lower Manhattan. Because of the double-ended design of the Staten Island ferryboats, it is impossible tell if the one in this picture is entering or leaving Whitehall.

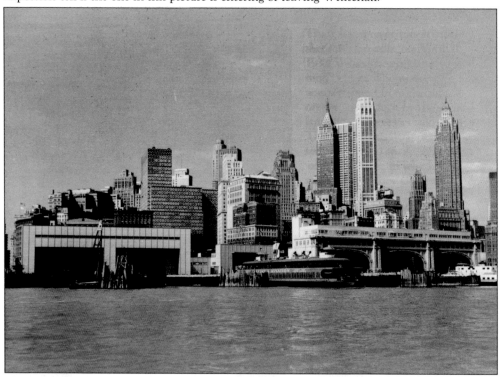

The ferryboat *Miss New York* sits in slip No. 3 and dock builders are in slip No. 1 in this panoramic 1940s view of Whitehall Terminal, with New York's Financial District rising behind it.

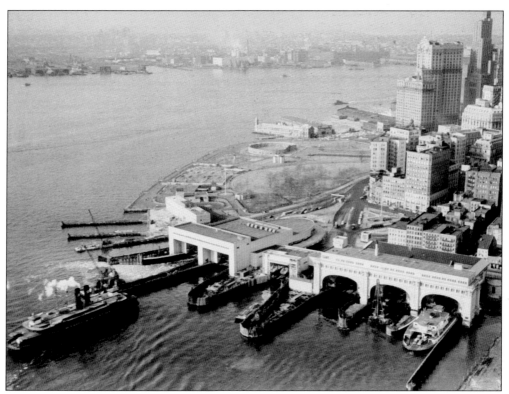

This aerial photograph, most likely taken from a helicopter, shows both the old and the new Whitehall Terminals. The relatively undeveloped land immediately northwest of the terminal, is Battery Park, lushly planted today. The ferry to Ellis Island and the Statue of Liberty leaves from the Battery; its ticket office is in the now restored Castle Clinton, the circular structure in the photograph. Castle Clinton was constructed during the War of 1812 to prevent the British from invading Manhattan.

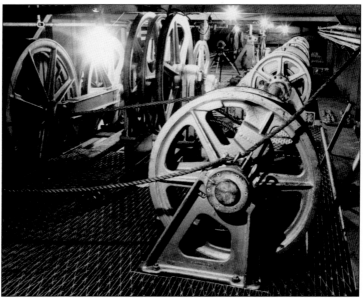

The wheels of slip No. 2 are shown here. This is a rare glimpse of the inner workings of the ferry's operations.

The new Whitehall Ferry Terminal opened on February 7, 2005, as the new "Gateway to the City." This terminal was designed to be modern and clean and to encourage tourists to take the free ferry ride across the harbor. (*Staten Island Advance*/Steve Zaffarano.)

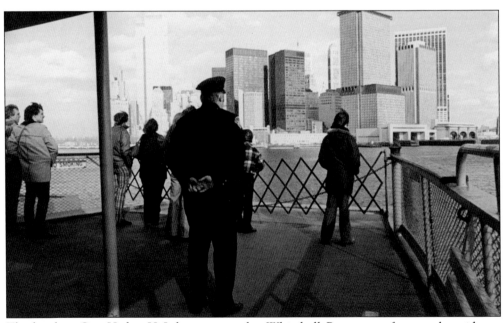

The ferryboat *Gov. Herbert H. Lehman* approaches Whitehall. Passengers often stand outside, no matter the weather, to enjoy the view or just to get some fresh air. Here, a New York City police officer stands with the passengers.

Five

ST. GEORGE TERMINAL

In 1902 and 1903, when the location for the Staten Island Ferry Terminal at Whitehall was being debated, a similarly contentious situation was taking place on Staten Island. Some called for terminals at West Brighten, Tompkinsville, Stapleton, or Port Richmond. In the end, Staten Island borough president George Cromwell sided with the Staten Island Rapid Transit Company and the Baltimore & Ohio Railroad, which then occupied the St. George Terminal. He declared that the ferry should remain at the St. George Terminal and promised a major overhaul of the site.

The Thirty-ninth Street, Brooklyn, ferry to St. George became a municipal operation in 1906 and continued to run until 1946, the year of the fire that destroyed the St. George Terminal. Ferry service between St. George and Sixty-ninth Street, Brooklyn, began on July 4, 1912. In 1939, the operation of this line came under the control of the Electric Ferries Company. Service ended on November 25, 1964, when it was deemed that the opening of the Verrazano-Narrows Bridge and an express bus route linking Staten Island to Brooklyn had made that ferry line obsolete.

The June 1946 fire that devastated the St. George Terminal was reportedly a nine-alarm blaze. All firefighters, including those off duty, were called into action, but the terminal, made mostly of wood, was utterly ruined and three people were dead. On June 8, 1951, five years after the fire, a new terminal opened, at the cost of $23 million. More than 50 years later, this terminal was completely refurbished at the cost of $30 million. It reopened to the public on May 29, 2005, at the same time that the new *Sen. John J. Marchi* ferryboat made its first trip across the harbor.

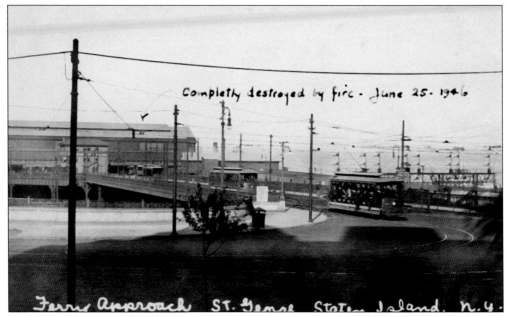

Completly destroyed by fire - June 25. 1946

Ferry Approach ST. George Staten Island. N.Y.

Seen here is the approach to the St. George Terminal on Staten Island, before the 1946 fire burned it down. Trolleys can be seen leaving the terminal, much as buses do today.

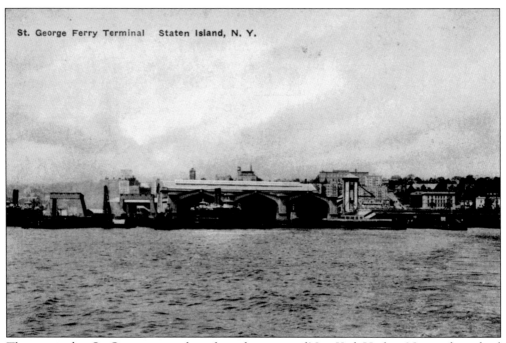

St. George Ferry Terminal Staten Island, N. Y.

The terminal in St. George is seen here from the waters of New York Harbor. Notice the radical difference between the skyline of Staten Island, which is mainly residential and is the least populated of the five boroughs of New York City.

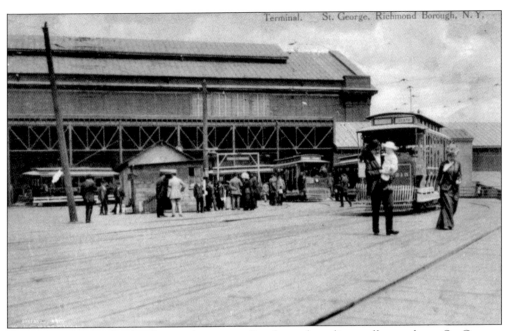

St. George Terminal is bustling with activity. People are boarding trolleys to leave St. George, and others are disembarking from them to take the ferry into Manhattan.

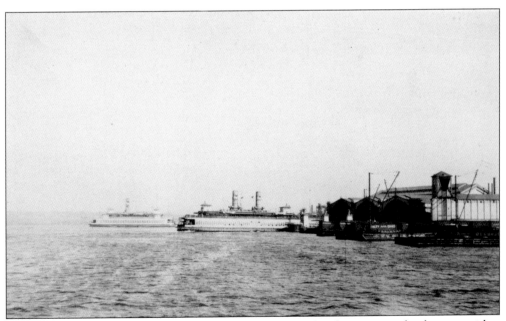

In this photograph of the St. George Ferry Terminal, two ferryboats are in the distance, either arriving or preparing to depart. Cargo ships and other vessels can also be seen.

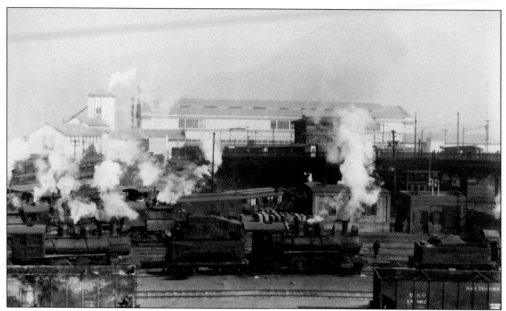

This 1930 photograph shows the Baltimore & Ohio Railroad Station and, beyond it, the Staten Island Ferry Terminal at St. George. A train still operates on Staten Island. It is part of the New York City Metropolitan Transit Authority and runs from St. George to Tottenville, at the other end of the island. Staten Island is the only borough not connected to the subway system.

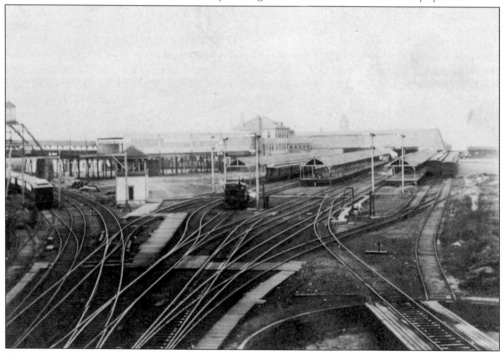

The Staten Island Ferry Terminal in 1901 was overshadowed by the rail yard that existed behind it. At one point, there were three different railroad lines leading to St. George: the North Shore, the South Beach, and the Main lines. The Main line, from St. George to Tottenville, is the one that remains active.

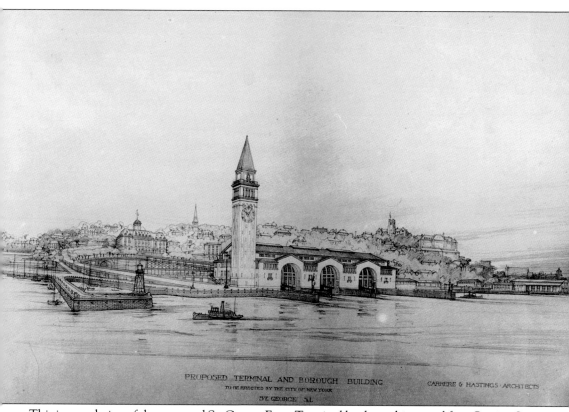

PROPOSED TERMINAL AND BOROUGH BUILDING
TO BE ERECTED BY THE CITY OF NEW YORK
ST. GEORGE S.I.

CARRERE & HASTINGS ARCHITECTS

This is a rendering of the proposed St. George Ferry Terminal by the architectural firm Carrère & Hastings. In the early 20th century, Carrère & Hastings successfully competed to design and build the main branch of the New York Public Library, which is now widely recognized as emblematic of the firm's Beaux-Arts style. The architects were active on Staten Island, overseeing construction of the Staten Island Ferry terminal (1901), Staten Island Borough Hall (1903–1906), and the Richmond County Courthouse (1913–1919). Some of the most famous Carrère & Hastings designs include Bellefontaine, the residence of Giraud Foster, in Lenox, Massachusetts; the McKinley Monument in Buffalo, New York; the approaches of the Manhattan Bridge in New York City; and the Russell Senate and Cannon House Office Buildings in Washington, DC. In 1911, John Carrère was killed in an automobile accident. Thomas Hastings continued to operate the firm under the same name until his death in 1929.

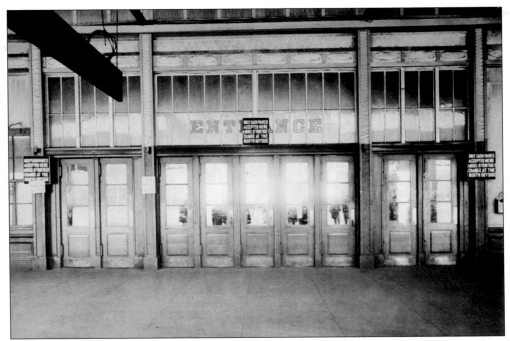

In this 1920 shot of the entrance to St. George Terminal, people can be seen inside the building. The signs above and to the sides of the doors read: "Only cash fares accepted here. A nickel is your ticket. Change at the booth outside."

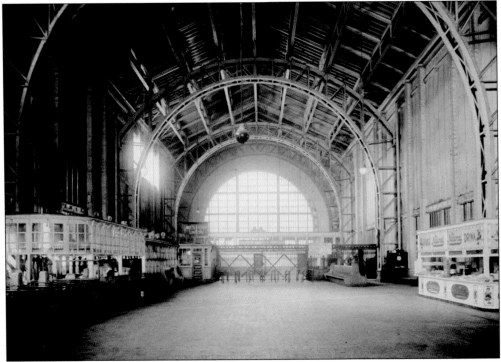

The high-ceilinged, vaulted ironwork interior of the old St. George Ferry Terminal was typical of railway station architecture. A snack bar is visible on the left, with men seated on stools.

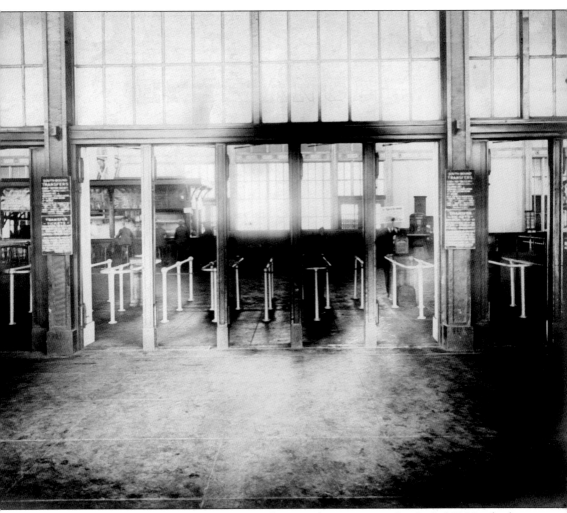

The interior of the St. George Ferry Terminal is seen here prior to the fire of 1946, which devastated the structure beyond repair. This terminal was enormous, attesting to the crowds that passed through it every day. Note the Western Union telegraph station at left and the snack bar at right.

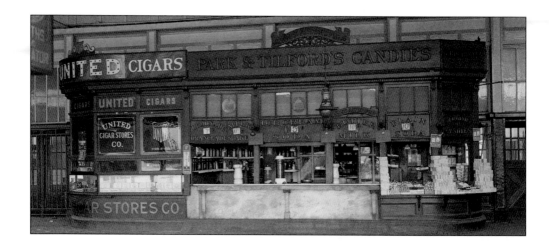

Places to purchase food and other items have long been staples at both the Whitehall and St. George Terminals. The 1919 glass plate negative above shows a cigar and refreshment stand in the middle of the St. George Ferry Terminal. The photograph below shows the lunch counter at the St. George Terminal, which offered Rubsam and Horrmann (R&H) beer, produced at one of the now defunct Staten Island breweries that thrived on the island in the 19th and early 20th centuries. This food stand offered items for breakfast, lunch, and dinner.

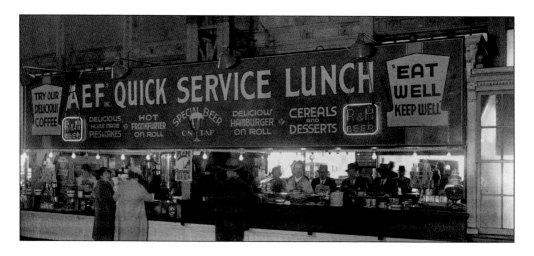

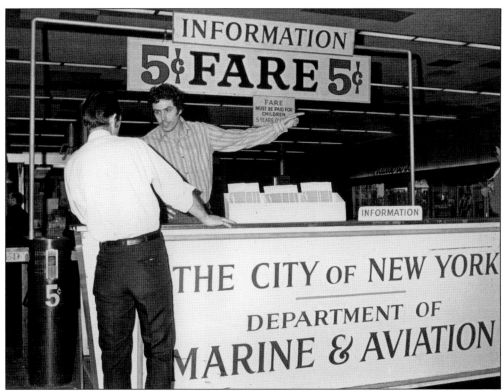

The ferry cost a nickel for everyone, including children five years old and up. For most of the 20th century, the ferry was famous for being the best bargain in New York City. It charged the same one-nickel fare as the New York City Subway. The ferry fare, however, remained a nickel when the subway fare increased to 10¢ in 1948.

In this 1931 photograph by Joseph Sheldefer, the lunch counter at St. George Ferry Terminal is ready to serve commuters. Eventually, snack bars and sit-down lunch counters within the terminal itself would cease to exist. Today, places to purchase food and drinks are in the pedestrian mall attached to the terminal.

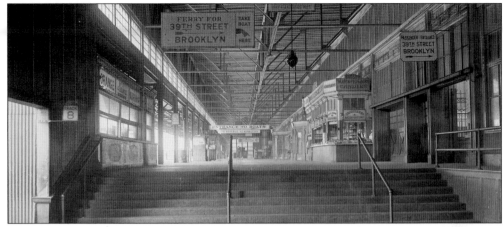

This glass plate negative shows the interior of the St. George Ferry Terminal's south entrance. Passengers wanting to go to Brooklyn on the Thirty-ninth Street Ferry line entered here. A snack bar or newsstand is visible on the right, and signs in the foreground and in the distance direct passengers.

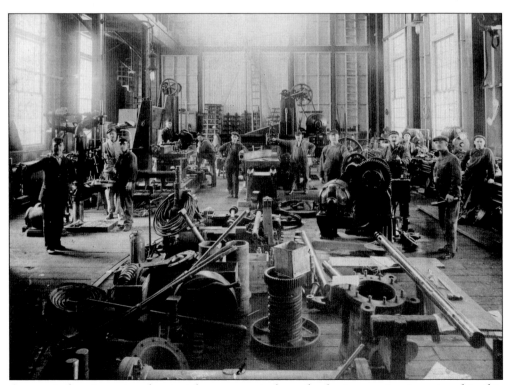

An array of equipment and materials necessary to keep the ferries running is captured in this photograph of the machine shop in the St. George Ferry Terminal. The workmen, some with tools in hand, take a break to pose for the photographer.

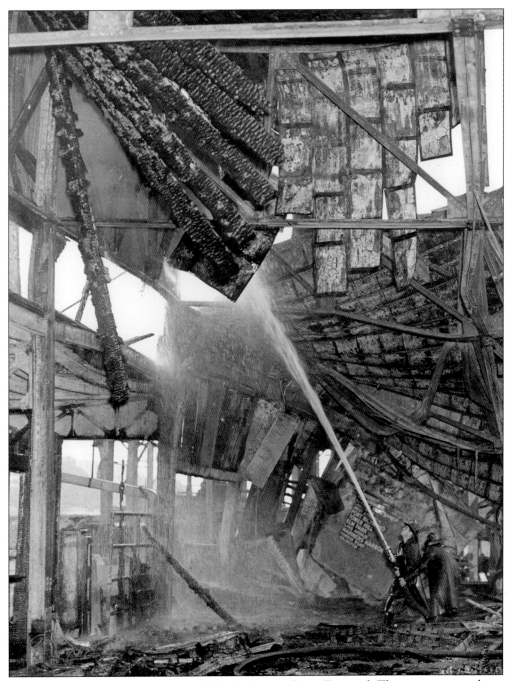

On June 26, 1946, a fire tore through the St. George Ferry Terminal. The entire terminal was damaged beyond repair and needed to be completely rebuilt. The utter destruction is evident in this photograph of firefighters still struggling to put out the blaze as it rages. A sign indicating the station stops of the North Shore railway line lies amid the ruins. (Anthony Lanza Collection.)

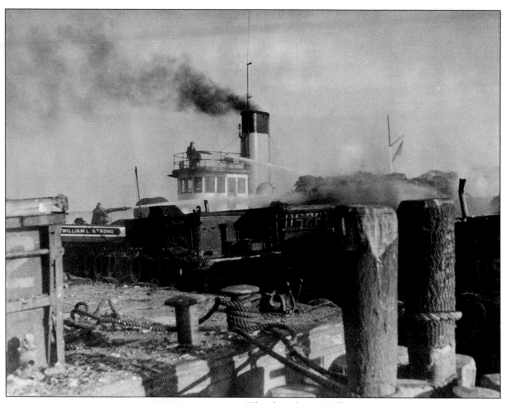

The ferryboat *William L. Strong* is called into service to assist the firefighters battling the blaze at the St. George Ferry Terminal in June 1946. The fire was so massive that all resources were called in to help, including ferryboats. Ferryboats were sometimes used in firefighting, but only to help put out small, shoreline fires. Despite the valiant efforts of all, the St. George fire could not be contained.

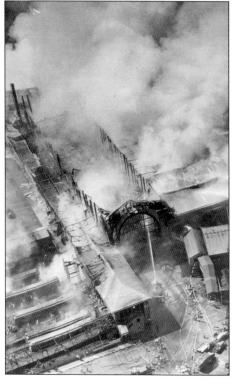

This is an aerial photograph of the fire that ravaged the St. George Ferry Terminal for several hours in June 1946. Someone with the US Army took this photograph from a helicopter. Fire trucks from all over the island responded in an attempt to put out the blaze.

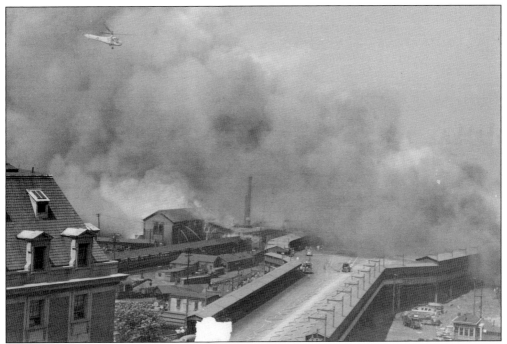

A helicopter hovers above the smoke of the fire that damaged the terminal at St. George. In the end, three people were dead and 34 were overcome or injured in the nine-alarm, $2 million blaze that engulfed the terminal. Luckily, the ferryboat *Miss New York* had just left the terminal, carrying 500 passengers. Otherwise, the death and injury toll would likely be much higher.

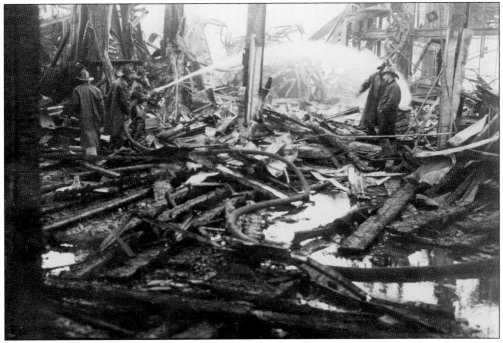

Water is still being used to put out small fires throughout the terminal to ensure the danger is completely eliminated. The blaze turned the terminal into a pile of twisted metal.

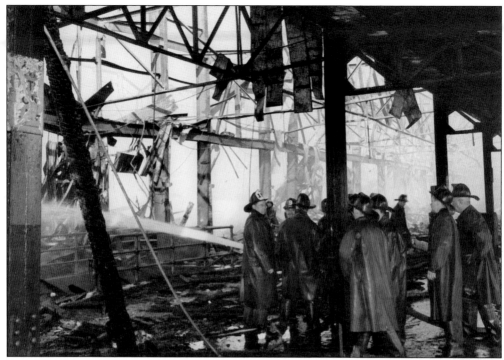

Firemen gather to discuss the situation at the St. George Ferry Terminal. All that is left of the building, now unrecognizable, is the outer shell. A fireman is still dousing the debris with water.

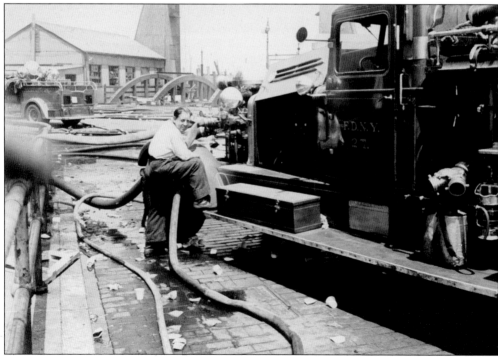

Shown here is one of the many firefighters who assisted with the blaze that ravaged the St. George Ferry Terminal. More fire trucks are visible in the distance.

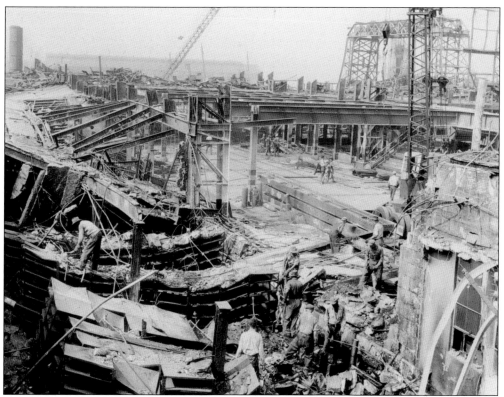

The full extent of the devastation caused by the fire is seen here, with men working to sift through the wreckage. Only twisted metal and the outer shell of the once grand structure remain. (Richmond Borough Collection.)

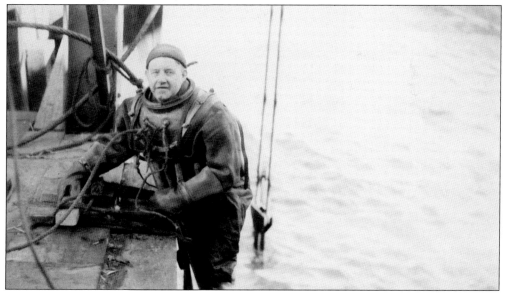

This photograph, taken on February 17, 1947, captures one of the construction engineers hired to help rebuild the St. George Ferry Terminal. His diver's suit was a product of the latest technology, helping insulate him from the frigid wintertime waters. (Richmond Borough Collection.)

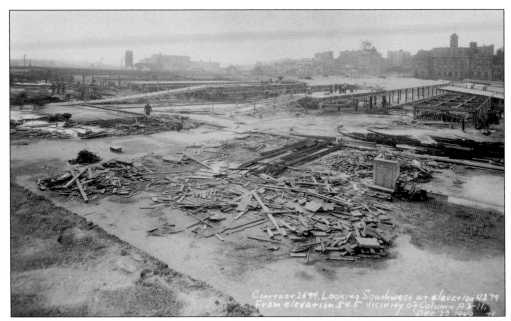

Most of the wreckage caused by the fire has been cleared away by the time this photograph, with a view looking southwest toward Borough Hall and Victory Boulevard, was taken on December 22, 1949, more than three years after the fire. The cleanup was a vast undertaking, but had to be done before the new terminal could be constructed.

The inscription on the back of this picture reads: "This photograph, taken on July 18, 1947, may be showing work on the northern ramp" of the St. George Ferry Terminal.

70

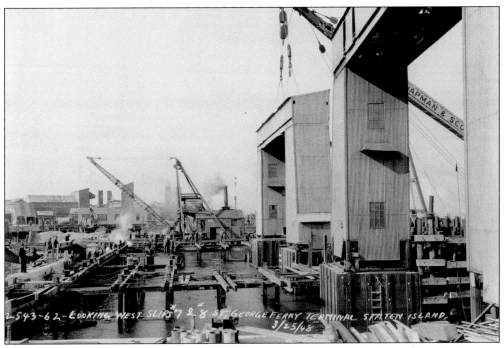

These two photographs record St. George from two different vantage points. The inscription on the image above reads: "Looking west, slips No. 7 and 8, St. George Ferry Terminal, Staten Island." The inscription on the image below reads: "Looking Southeast at Ferry Bridge from West Slip No. 8. Parts of St. George can be seen in the background, along with a large 7UP advertisement perched on top of a tall building. Men, presumably workers, stand on the docks."

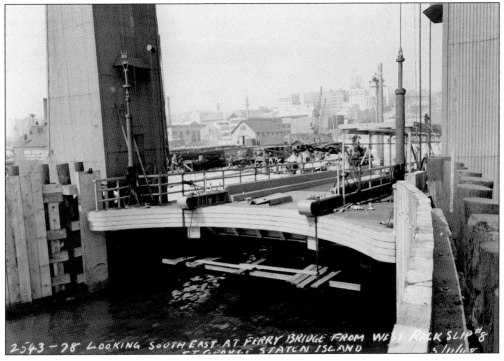

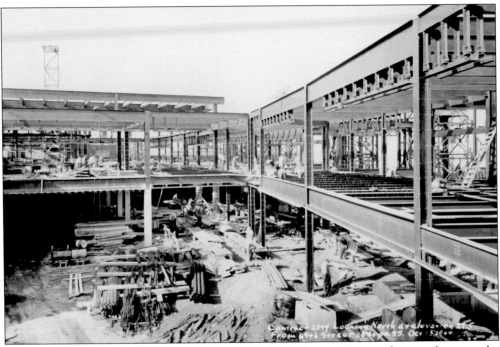

Construction of the new St. George Ferry Terminal is under way. During the years between the fire and the completion of the new terminal, ferry service ran from nearby sites that were not fully equipped with amenities.

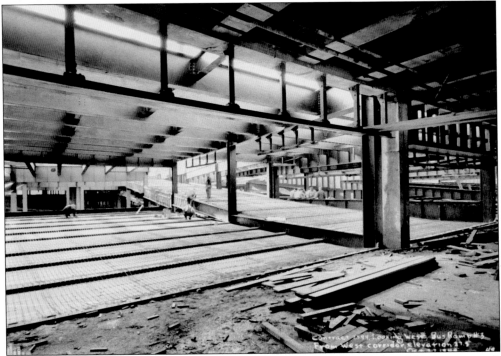

This photograph, taken on October 27, 1949, offers a view of the west corridor of the new terminal, where construction on bus ramp No. 3 is taking place.

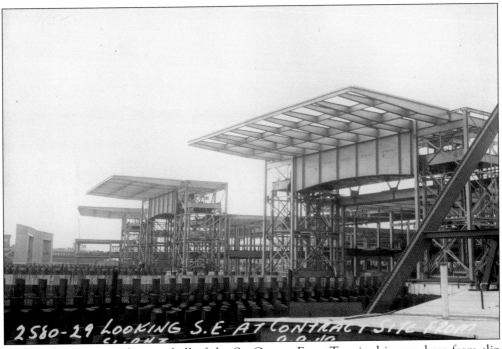

The newly constructed outer shell of the St. George Ferry Terminal is seen here from slip No. 3.

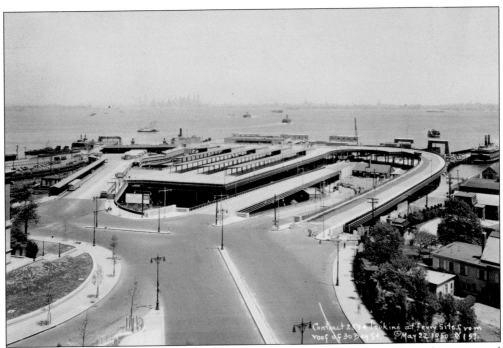

This photograph, taken from the roof of 30 Bay Street on May 22, 1950, shows the newly constructed bus ramp at the St. George Ferry Terminal. Note the boat traffic in the busy waterway and the Manhattan skyline beyond.

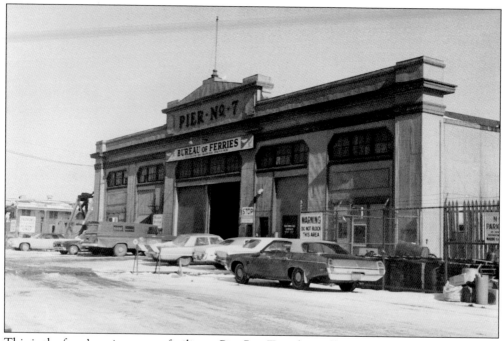

This is the ferry's maintenance facility at Pier 7 in Tompkinsville, Staten Island, which lies just south of the St. George Terminal. Given the style of the cars parked in front of the building, the photograph likely dates from the 1970s.

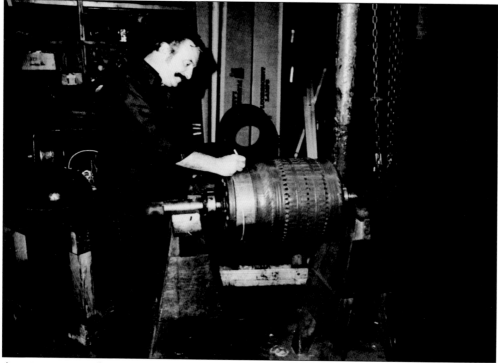

A maintenance technician is at work inside the Pier 7 ferry maintenance facility. This photograph was taken in August 1975.

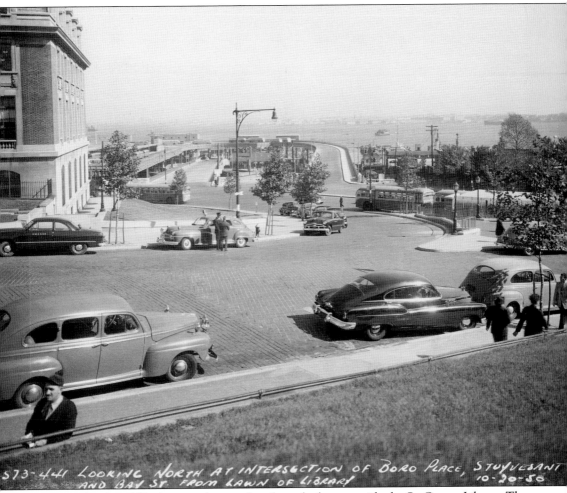

573-441 LOOKING NORTH AT INTERSECTION OF BORO PLACE, STUYVESANT
AND BAY ST. FROM LAWN OF LIBRARY 10-20-50

This October 20, 1950, photograph was taken from the lawn outside the St. George Library. The building to the left is Staten Island Borough Hall, and the bus terminal appears beyond. Note the Staten Island ferryboat making its way across the harbor.

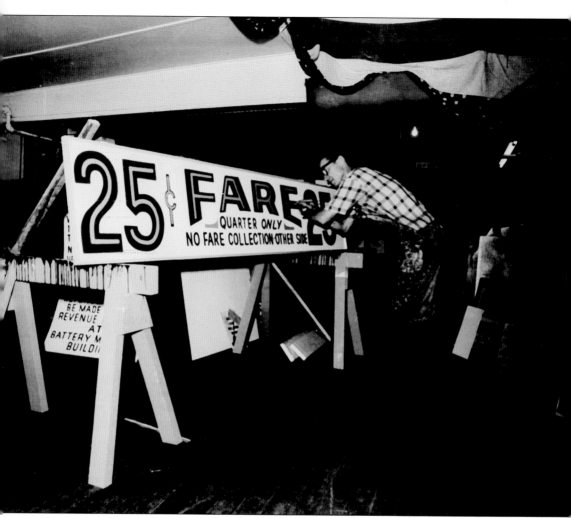

The 5¢ fare was raised to 25¢ in 1975. In 1970, Mayor John V. Lindsay proposed the fare increase, pointing out that the cost for each ride was 50¢, or 10 times what the fare brought in. On August 4, 1975, the new fare went into effect. The 25¢ fare was for a round-trip, the quarter being collected in one direction only. The fare increased to 50¢ in 1990, but it was eliminated altogether in 1997.

Six

FERRYBOAT CLASSES
THROUGH THE YEARS

Bids for new ferryboats were announced by Richmond borough president George Cromwell and a number of prominent Staten Islanders on June 10, 1904. These five vessels became the Borough class of ferryboats, the first class of Staten Island ferryboats to be owned by New York City. The new class of boats included the *Bronx*, *Brooklyn*, *Queens*, *Manhattan*, and *Richmond*.

The *Mayor Gaynor*, *President Roosevelt*, and the first *American Legion* were each built as independent ferries, meaning that they were not included in any particular class. They are referred to as single-class ferries.

The *Dongan Hills* was delivered for service in 1928. It held 26 cars and 2,250 passengers. The *Tompkinsville* was delivered in September 1930, and its identical twin, the *Knickerbocker*, was delivered in October 1931. The *Dongan Hills* had a gross tonnage of 2,030, while the *Knickerbocker* and the *Tompkinsville* weighed in at 2,045 tons each. All three had a superstructure and decks made of wood, and their interiors featured main cabins with attractive, dark wood paneling in the best steamboat tradition. These were the Dongan Hills class of Staten Island ferryboats.

The Mary Murray class consisted of a trio of two-tiered ferries: the *Mary Murray*, *Gold Star Mother*, and *Miss New York*. The three ships, built at United Shipyards in Mariners Harbor, Staten Island, were the first to have oil-fired, instead of coal-fired, boilers.

The three-tiered Merrell class consisted of the *Pvt. Joseph F. Merrell*, *Cornelius G. Kolff*, and *Verrazzano*. These boats were designed by the firm of Kindlund & Drake and were built at the Bethlehem Steel Corporation on Staten Island between 1950 and 1951.

Less than eight years after the arrival of the Merrell class, the Kennedy class of boats was added, consisting of the *John F. Kennedy*, *Gov. Herbert H. Lehman*, and *American Legion*.

In the spring of 1982, the *Andrew J. Barberi* was introduced to the line. This boat was built in New Orleans by Equitable Shipyards and went into service in late 1981. The *Samuel I. Newhouse* is its sister ship. These Barberi-class ferryboats have the largest seating capacities of any Staten Island ferry, with room to accommodate 6,000 passengers each.

The *Alice Austen* and the *John A. Noble*, placed into service in 1986, make up the Austen class of the Staten Island Ferry. Each requires nine crew members and one attendant to operate. At 207 feet long, they are the smallest boats in the fleet and are used mainly at nights and on weekends.

The final class of ferryboats is the Molinari class, comprised of the *Spirit of America*, the *Senator John J. Marchi*, and the *Guy V. Molinari*. At 310 feet each, these vessels carry 4,400 individuals and 42 vehicles.

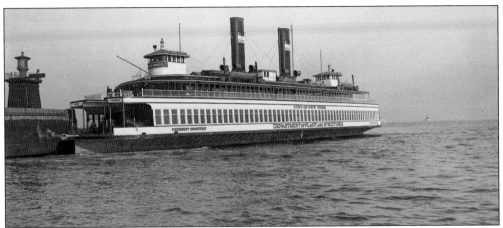

The *President Roosevelt* is at the edge of the slip at St. George on a trial run after being delivered by the Staten Island Shipbuilding Company in 1921. The *President Roosevelt* was a single-class vessel, meaning that it was built independently and there are no other boats in this class.

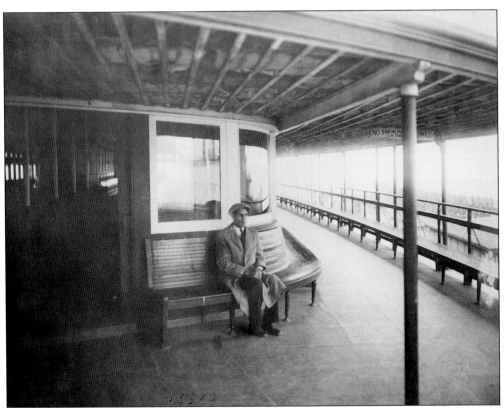

A passenger sits in the outside promenade on the *President Roosevelt* around 1932. This ship was built in 1921, and its name refers to Pres. Theodore Roosevelt, whose term ran from 1901 to 1909. Pres. Franklin Roosevelt, Theodore's distant cousin, was elected in 1932. This ferryboat served the people of Staten Island for more than three decades before it was taken out of service.

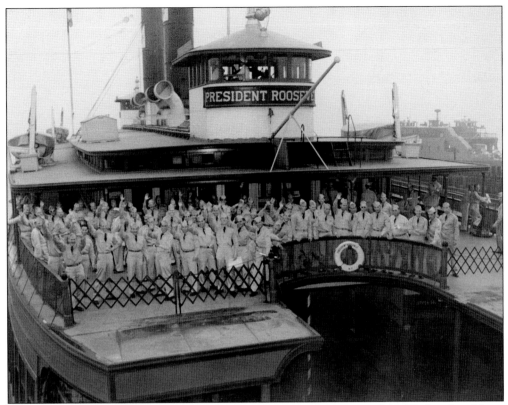

In this photograph, taken during World War II, the *President Roosevelt* is filled with soldiers. This ferry was built at the Staten Island Shipbuilding Company in Mariners Harbor. One of the founders of the Staten Island Museum, William T. Davis, attended its launch in 1921.

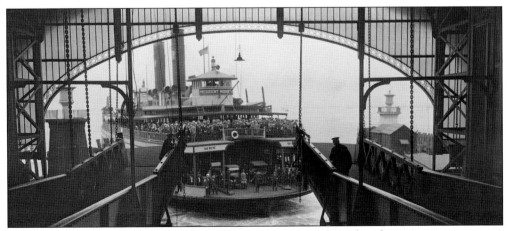

The *President Roosevelt* approaches the St. George Ferry Terminal with passengers waiting to disembark. On April 3, 1956, the Purchasing Department of the City of New York announced that after more than three decades of service, the usefulness of the *President Roosevelt* had ceased. The ferryboat was "retired as uneconomical to operate" and sold "as is."

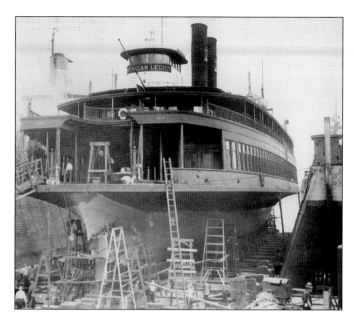

The ferryboat *American Legion* is seen in dry dock around 1932. This single-class boat was delivered in February 1927. Like the *President Roosevelt*, the *American Legion* was built at Staten Island Shipbuilding in Mariners Harbor. This was the first *American Legion*; a second boat of the same name sailed in 1965, and a third vessel with this name followed in 2007. Today's *American Legion* does not transport passengers. It is used for responding to water-related emergencies in New York Harbor.

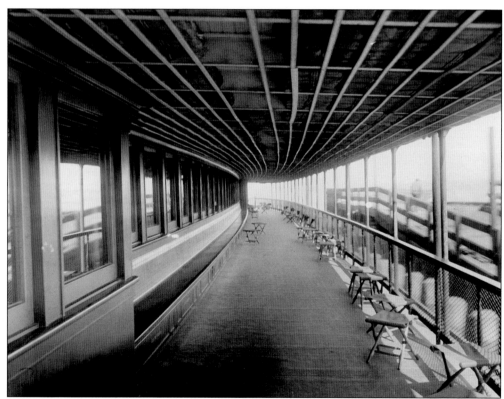

This photograph shows the outside seating area of the ferryboat *Mayor Gaynor*. Built in 1914, it was withdrawn from service in 1950. The boat was always considered to be rather sluggish and was never a favorite of ferryboat captains. It serviced Staten Island for over 36 years.

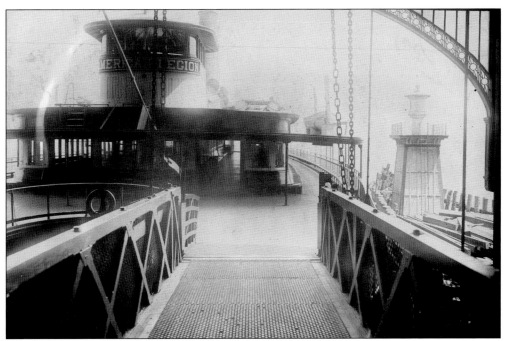

This photograph was taken on the upper deck of the ferryboat *American Legion*. The vessel is docked and ready to take on passengers for the return trip.

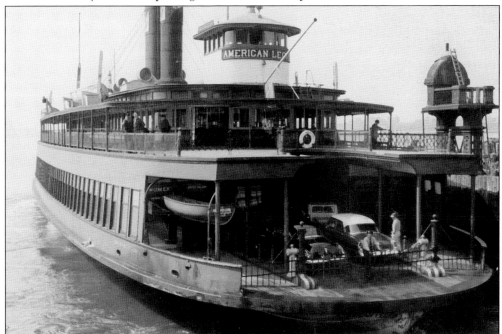

The *American Legion* is northbound off of Governors Island. The first *American Legion* is said to have sailed past the Statue of Liberty 420,000 times while accumulating more than 560,000 miles during her 34 years of service. Owing to a flawed design, the automobiles, deckhands, and riders on the vehicle gangways of the original *American Legion* were doused with saltwater spray while the vessel was in motion.

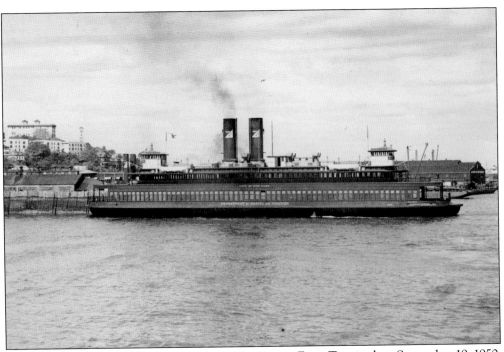

The ferryboat *Dongan Hills* is shown leaving St. George Ferry Terminal on September 19, 1950. It had the capacity to hold 26 cars and 2,250 passengers and was part of the second group of ferryboats, the Dongan Hills class.

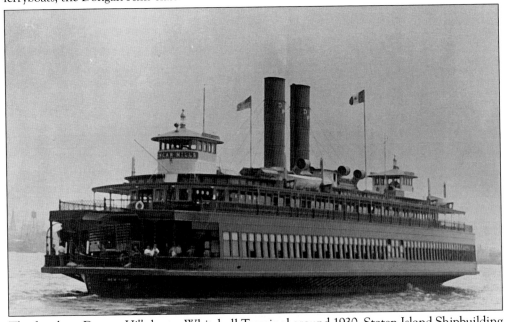

The ferryboat *Dongan Hills* leaves Whitehall Terminal around 1930. Staten Island Shipbuilding in Mariners Harbor built the *Dongan Hills*. The ferryboat sustained damage on November 29, 1930, when it was hit by the Norwegian tanker *Tornes* in a bank of fog. Another hit was taken on February 8, 1958, at around 8:11 p.m., when the *Dongan Hills* collided with the British tanker *Tynefield* as the ferryboat headed to St. George.

The ferryboat *Knickerbocker* is christened at Staten Island Shipbuilding Company around 1931. At front, from left to right, are the flamboyant New York City mayor Jimmy Walker and his mistress, Betty Compton, and Comdr. M.B. Goldman and his wife, who is holding a champagne bottle. As a protection from bad luck, new vessels are traditionally christened by smashing a bottle of champagne against the hull.

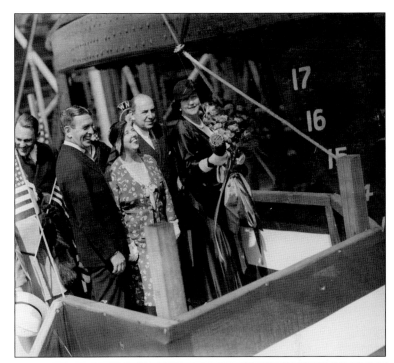

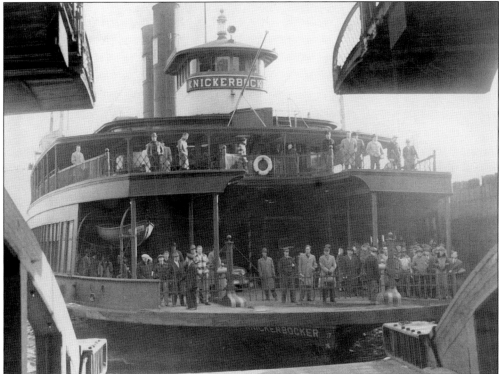

The ferryboat *Knickerbocker* approaches Whitehall Terminal in 1932. This boat was named after Diedrich Knickerbocker, the character created by Washington Irving for his satirical *A History of New York*. The term became shorthand for a quintessential New Yorker.

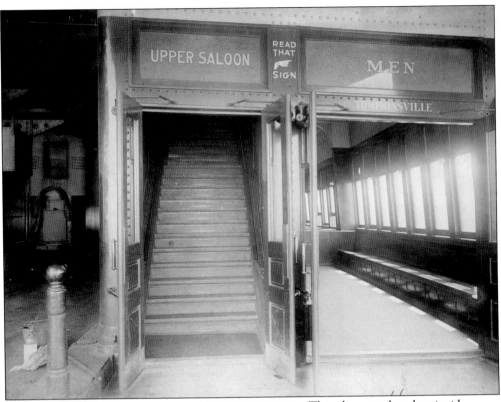

This photograph, taken inside the *Tompkinsville*, on April 21, 1932, shows the entrance to the men's cabin. The women's cabin was separated from the men's on the lower deck by the stairs leading to the upper saloon. The system was designed to give men a place to smoke and single women an area in which to sit separately, if they chose to.

On October 23, 1960, a bomb was planted aboard the *Knickerbocker*. The explosion blasted apart benches, caused a fire, and blew a two-foot hole in the deck. Luckily, because cold air from a broken window had prevented passengers from sitting in the cabin where the bomb went off, no one was injured. The act was the work of a man known as the "Sunday Bomber," who had already set off several bombs in Manhattan. He was never caught.

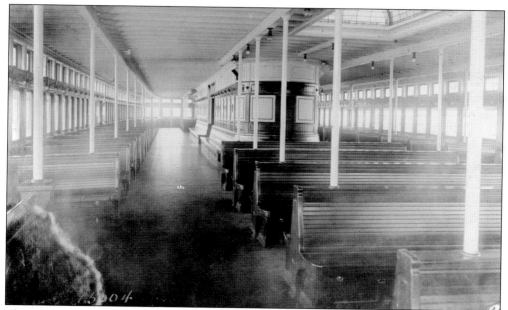

This photograph, taken on February 23, 1932, shows the saloon deck of the *Tompkinsville*. The *Tompkinsville* weighed in at 2,045 tons, 15 tons heavier than the *Dongan Hills*. All three boats of the Dongan Hills class had a superstructure and decks made of wood, and their interiors featured main cabins with attractive dark-wood paneling in the best steamboat tradition.

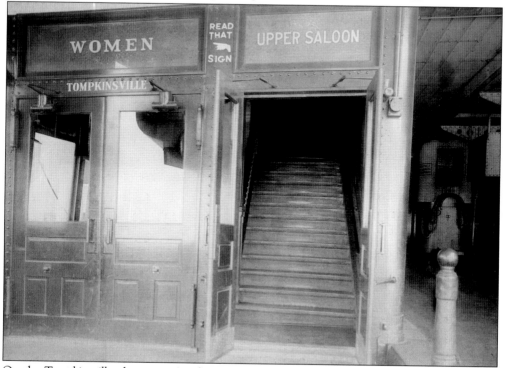

On the *Tompkinsville*, the women's cabin entrance was the mirror image of the entrance to the men's cabin on the opposite side of the lower deck. To avoid mistakes, passengers were reminded to "Read That Sign."

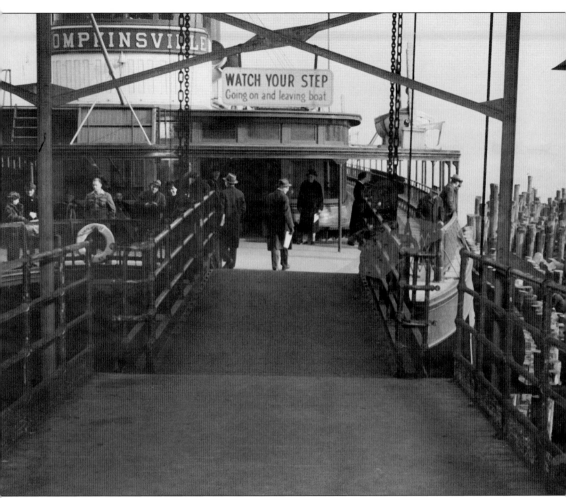

The ferryboat *Tompkinsville* is almost finished loading passengers, and it will soon leave one terminal for the other. When the Dongan Hills class ferryboats neared the end of their usefulness, the City of New York was anxious to retire them, given the expense of maintaining their elaborate wooden cabinetwork. In addition, their wood construction meant they were potential fire hazards. The more modern Kennedy-class boats replaced them.

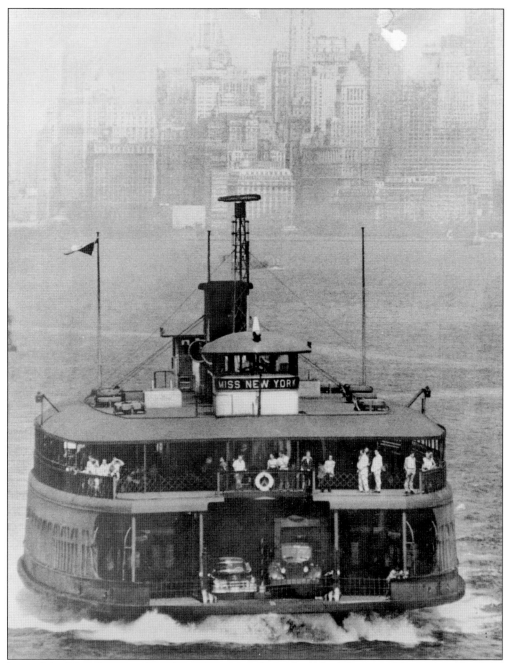

Part of the Mary Murray class, the *Miss New York* was launched in 1938 and is seen here in the 1940s. Almost without exception, Staten Island ferryboats, including *Miss New York*, were built at shipyards on Staten Island.

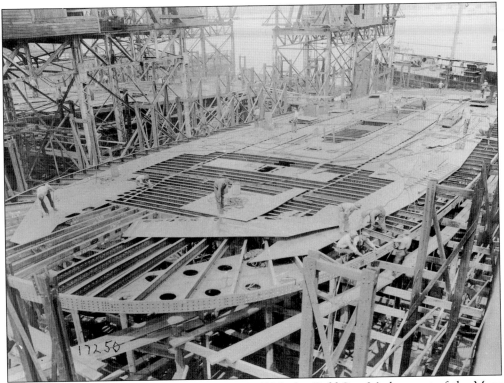

In the above photograph, taken on August 4, 1936, the *Gold Star Mother*, part of the Mary Murray class, is shown during an early phase of construction. Much progress has been made by the time the below photograph was taken on April 29, 1937. The *Gold Star Mother* went out of service in 1958.

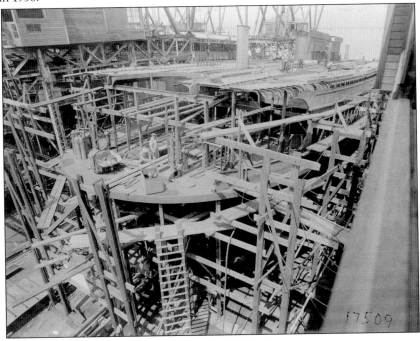

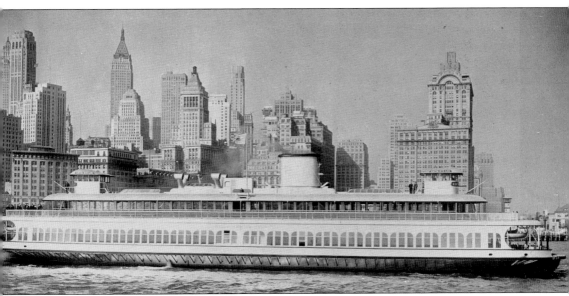

The *Gold Star Mother* was named after mothers who had lost sons in World War I. This ship, along with the *Mary Murray* and *Miss New York*, were the first to have oil-fired boilers as opposed to coal-fired boilers. These three boats of the Mary Murray class were also the first Staten Island Ferries to have smoking cabinets for women. Previously, smoking was allowed only in the men's cabin. In the company of a group of Gold Star Mothers, headed up by Mathilde Burling, national president of the American Gold Star Mothers of the World War, the ferryboat slid down the ways on May 7, 1937, at Mariners Harbor, Staten Island. New York City mayor Fiorello LaGuardia and at least a thousand others attended the launch.

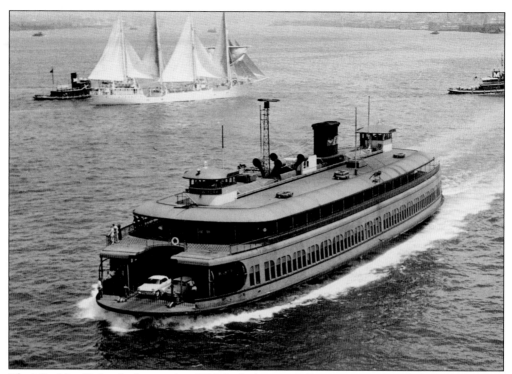

The *Miss New York*, which set sail in 1938, had a long and illustrious career with the Staten Island Ferry. Like many other boats, the *Miss New York* was involved in its share of accidents over the years. In one instance, while it traveled across the harbor one day in August 1940, a thick fog rolled in. With visibility severely limited, the *Miss New York* and the 9,500-ton tanker *Magnolia* collided, and six people were injured.

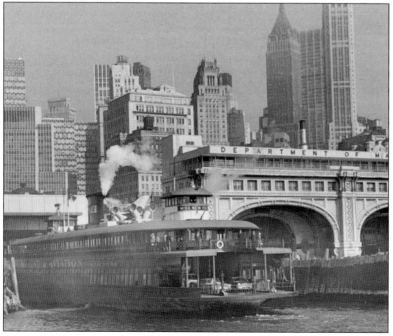

The *Miss New York*, seen here in slip No. 3 at Whitehall, boasted the Staten Island Ferry system's first onboard snack bar. Opened on June 30, 1950, it sold ice cream, pastries, sandwiches, soft drinks, and hot dogs.

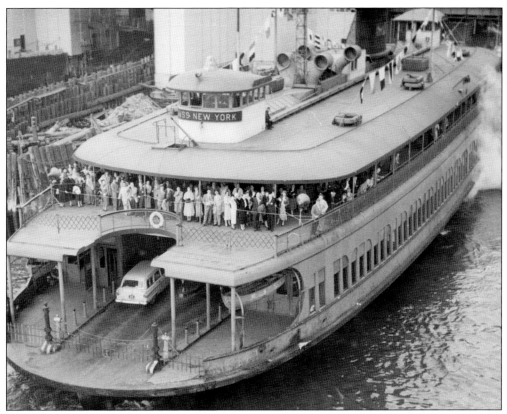

Miss New York is seen here in old slip No. 3 at Whitehall Ferry Terminal in the 1940s. The upper saloon is crowded with passengers waiting for the ferry to leave Whitehall and head for Staten Island.

On August 6, 1975, the City of New York auctioned off the *Miss New York* to Hall & Reis, Inc., a company known for buying and selling heavy industrial equipment. During the auction, someone bid $100 just for the boat's whistles.

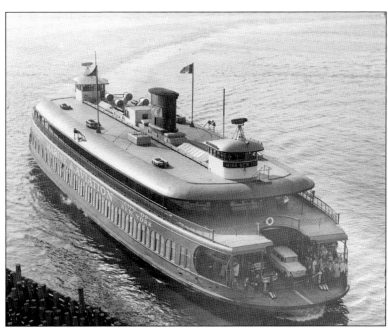

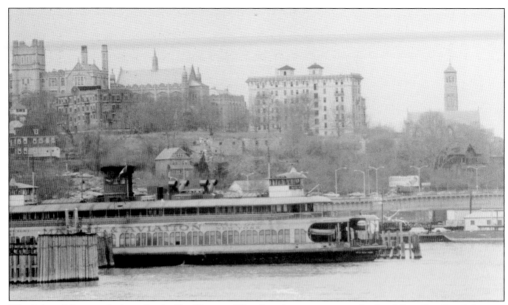

The *Mary Murray* sits in a slip in St. George. The ferryboat was named after Mary Lindley Murray, a Quaker and the wife of wealthy and powerful Robert Murray, who was loyal to Britain during the Revolutionary War. According to legend, Murray distracted General Howe, commander of the British forces, by entertaining him at the Murrays' Manhattan estate, giving Gen. Israel Putnam's American troops time to escape. Her portrait hung in the main cabin of the ferry named in her honor. (Robert Linden Collection.)

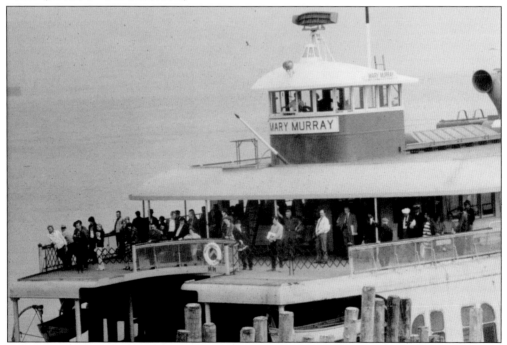

The *Mary Murray* lacked a telephone and radio; so when the captain needed to communicate with the engine room, he used a speaking tube, standard on naval and other vessels of the time. Cowbells and a small gong also served as means of communication. (Robert Linden Collection.)

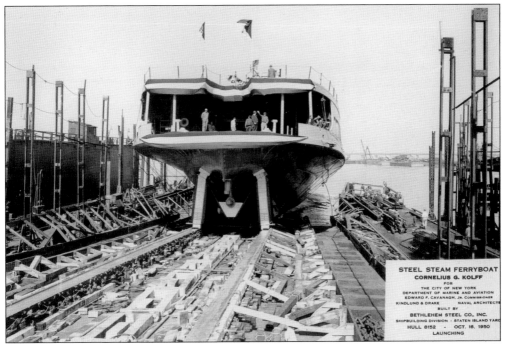

STEEL STEAM FERRYBOAT
CORNELIUS G. KOLFF
FOR
THE CITY OF NEW YORK
DEPARTMENT OF MARINE AND AVIATION
EDWARD F. CAVANAGH, Jr. COMMISSIONER
KINDLUND & DRAKE NAVAL ARCHITECTS
BUILT BY
BETHLEHEM STEEL CO., INC.
SHIPBUILDING DIVISION · STATEN ISLAND YARD
HULL 8152 · OCT. 16. 1950
LAUNCHING

Above, the *Cornelius G. Kolff* is launched on October 16, 1950. The *Kolff*, the *Pvt. Joseph F. Merrell*, and the *Verrazzano* made up the Merrell class of boats. These three-tiered ferryboats were built at the Bethlehem Steel Corporation shipyard on Staten Island. Below, the *Pvt. Joseph F. Merrell* is pictured on January 10, 1951.

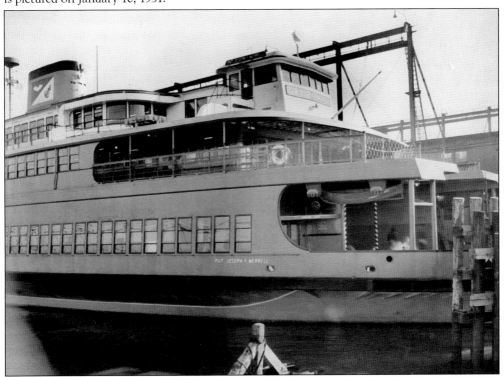

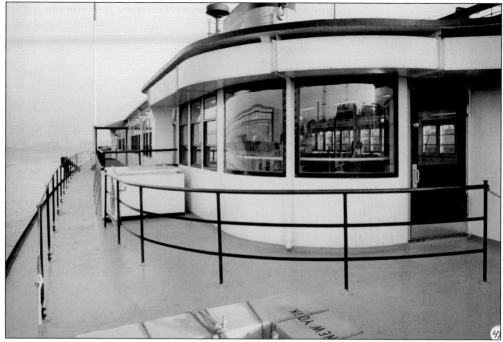

The modern design of the *Pvt. Joseph F. Merrell* is evident in the rounded corners and large expanses of single-paned glass of the bridge deck cabin. The exterior passageway surrounding the cabin allowed passengers to move more freely and quickly during rush hours.

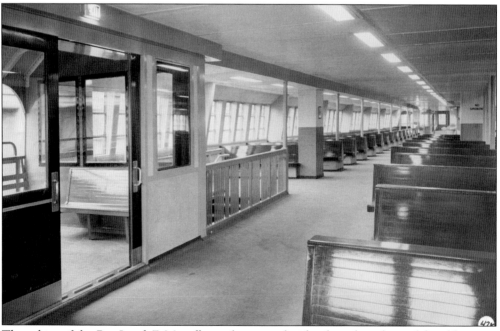

The cabins of the *Pvt. Joseph F. Merrell* were longer and wider than the cabins of the older, two-deck ferries. The upper cabin, seen here, had a steel deck with fire-resistant, rubberized covering and walls and ceilings of aluminum with insulated paneling.

This is the first-class pilot license of Capt. Peter Merli of the Staten Island Ferry. He received this on March 4, 1914. Merli was a seasoned ferry captain with over 50 years of experience when he had to guide a ferryboat through thick fog without radar. He used all of his knowledge to safely guide the ferry to the other side.

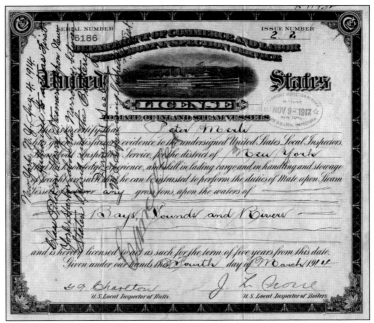

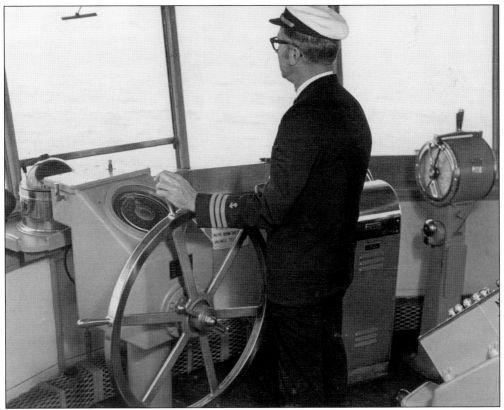

This c. 1965 photograph shows a ferryboat captain at the helm of the *John F. Kennedy*. The Kennedy class consisted of the *John F. Kennedy*, the *Gov. Herbert H. Lehman*, and the *American Legion*, designed by Kindlund & Drake of New York City.

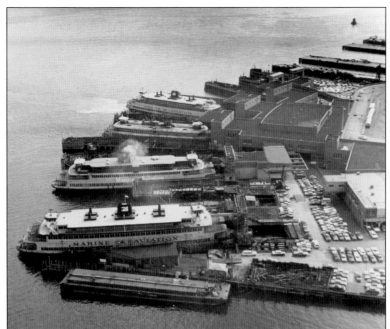

Here, three different classes of boats are docked at the St. George Terminal. Pictured are, from bottom to top, the Kennedy class, Mary Murray class, Merrell class, and another Kennedy-class boat.

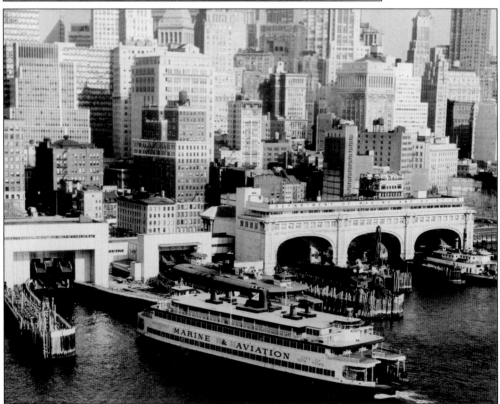

This dramatic shot shows the *John F. Kennedy* in service at Whitehall Terminal, with Manhattan's Financial District rising behind it. The ferryboat required 13 crew members and one attendant and had a capacity of 3,500 passengers and 40 cars.

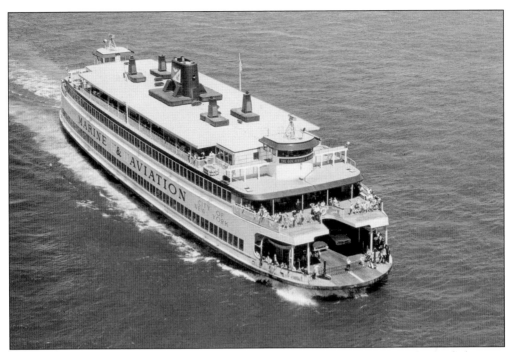

The *Gov. Herbert H. Lehman* is on a run across New York Harbor, as seen from a helicopter in September 1981. The *Gov. Herbert H. Lehman* was launched in 1955. Herbert Lehman's granddaughter, Wendy Lehman, was on hand to christen the ship.

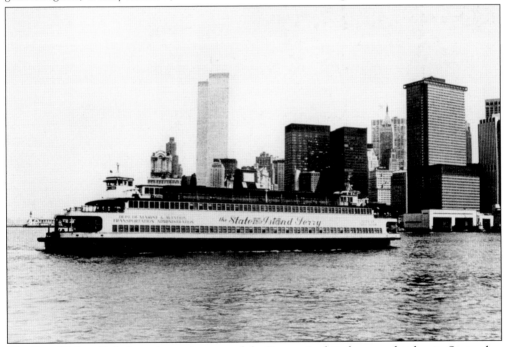

The *Gov. Herbert H. Lehman* is coming around the Battery in this photograph taken in September 1981. The twin towers of the World Trade Center, which formally opened on April 3, 1973, are at the center of the image.

The spring of 1982 saw six boats operating between Staten Island and Whitehall. They were the *Cornelius Kolff*, the *Pvt. Joseph F. Merrell*, the *John F. Kennedy*, the *American Legion (II)*, the *Gov. Herbert H. Lehman*, and the recently introduced *Andrew J. Barberi*. The *Barberi* (right) was built in New Orleans by Equitable Shipyards and went into service in late 1981.

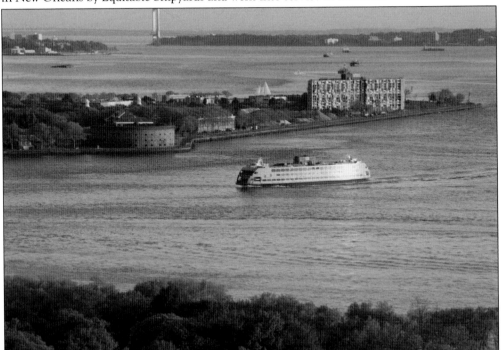

A Staten Island Ferry passes Governors Island, a military base for 200 years and now a public park. It lies only 800 yards from Lower Manhattan. The Verrazano-Narrows Bridge is visible in the distance. (*Staten Island Advance*/Steve Zaffarano.)

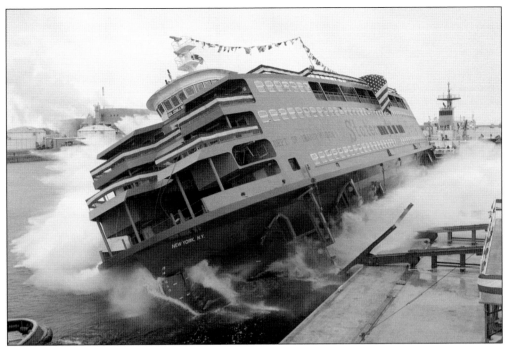

The ferryboat *Sen. John J. Marchi* is launched on May 8, 2004. The *Marchi* is part of the Molinari class of ferryboats, which also includes the *Spirit of America* and *Guy V. Molinari*. At 310 feet in length, these vessels carry 4,400 individuals and 42 vehicles. (*Staten Island Advance*.)

This photograph shows the *Spirit of America* heading across the harbor. The Molinari class was designed to incorporate the best aspects of the Kennedy class and the more modern Barberi class. These boats feature air-conditioning, elevators, and display portals that showcase the harbor floor. (*Staten Island Advance*/Irving Silverstein.)

The *Samuel I. Newhouse* was put into service in the summer of 1982. Named for the 20th-century magazine and newspaper publisher, it is identical to the *Andrew J. Barberi*, the only other ferry in the Barberi class. Each has the capacity to accommodate 6,000 passengers. (*Staten Island Advance*.)

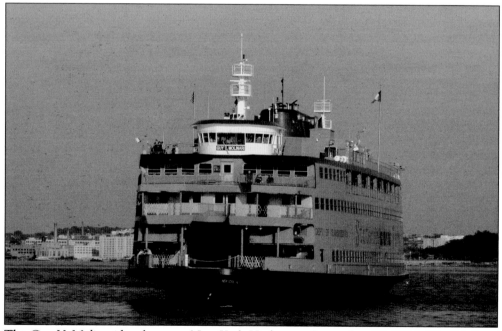

The *Guy V. Molinari* heads across New York Harbor on September 26, 2004. The *Molinari* was introduced to the riding public on January 26, 2005. Molinari, a former New York State assemblyman and US congressman, served as Staten Island borough president from 1990 to 2001. (*Staten Island Advance*.)

Seven

ON BOARD THE FERRY

Throughout the history of the Staten Island Ferry, there have been many different types of celebrations. When a new boat is launched, it is celebrated with the breaking of a bottle of champagne. This rite has been repeated time and time again. Babies have been born on ferries, and couples have become engaged on ferries, all of which call for celebrations.

In 1980, the diamond jubilee of the Staten Island Ferry was celebrated with a festive balloon launch, musical performances, a chess tournament, art exhibits, and a poster contest held by the *Staten Island Advance*.

Another major event in Staten Island Ferry history happened in June 1982, when Anna Mae the Elephant came from Manhattan for a stint at the Snug Harbor Cultural Center.

When the Staten Island Ferry celebrated its 75th anniversary of operation under municipal service by the city, the celebration occurred on the ferry. Celebrations happen on the ferry when sports teams win championships, as people use the ferry as a means to get to the parades. The ferry means a lot to many different people, and that is one of the things that make it so interesting and unique.

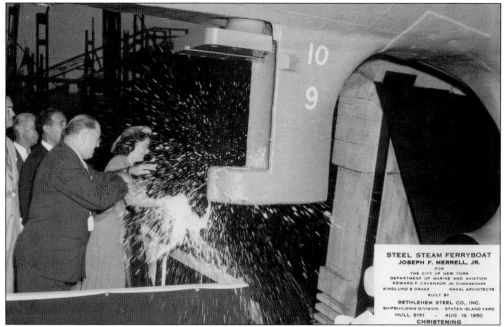

The christening of the *Pvt. Joseph F. Merrell* took place in August 1950. Pvt. Joseph F. Merrell, a graduate of Staten Island's Curtis High School, was killed in action on April 18, 1945, and was posthumously awarded the Medal of Honor. Staten Island American Legion Post 1368 was also named in Merrell's honor.

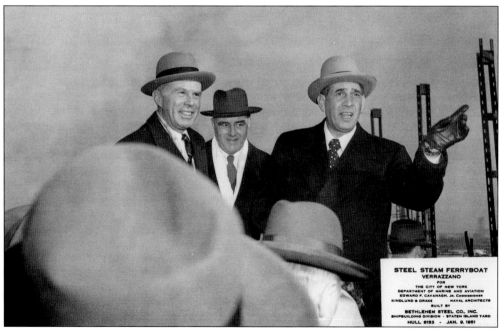

Shown here is the launching party of the ferryboat *Verrazzano* on January , 9, 1951. The *Verrazzano* struck the anchor chain of the Norwegian freighter *Norlindo* on January 20, 1954, off Bedloe's (now Liberty) Island. Seven passengers were injured and the ferry sustained damage to some of its windows and railing.

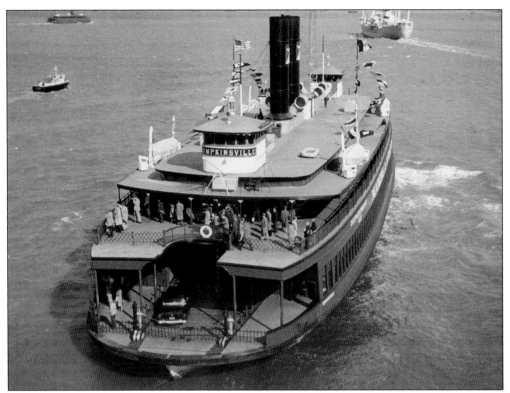

On October 25, 1955, the 50th anniversary of New York City's ownership of the Staten Island Ferry was celebrated aboard the *Tompkinsville*. These two photographs show it on that day, making its way across the harbor with an escort of a police helicopter and a US Coast Guard boat.

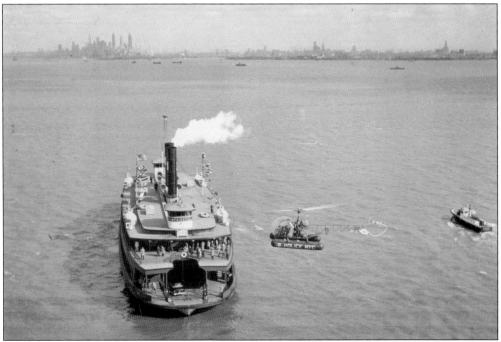

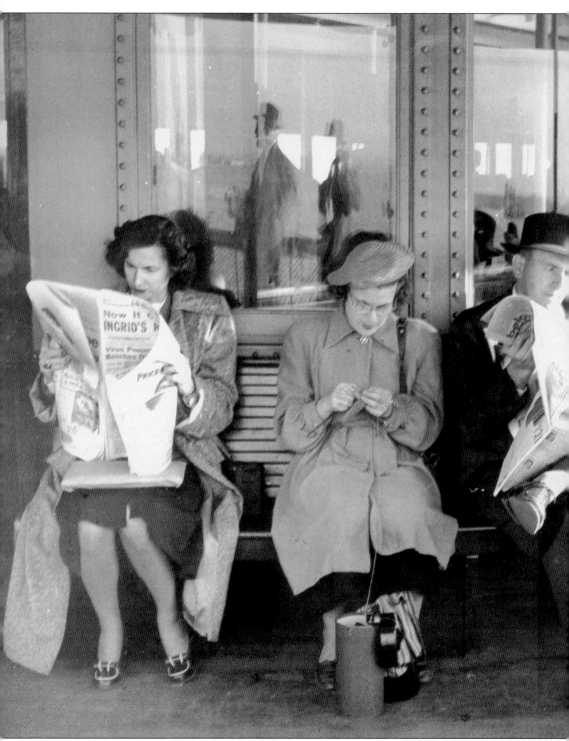

This iconic image, taken by Anthony Lanza in the 1940s, beautifully conveys the experience of regular commuters on the Staten Island Ferry. Taking this trip daily, they pay less attention

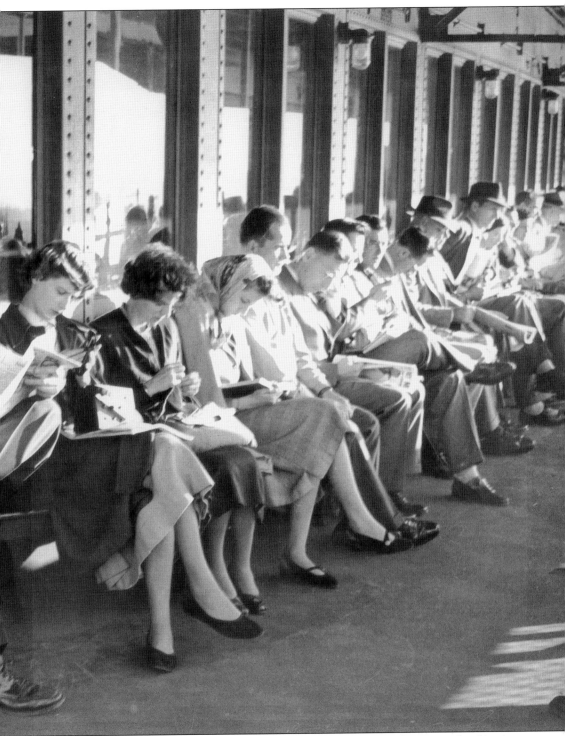

to the spectacular view than those tourists and others for whom the ride is a novelty. (Anthony Lanza Collection.)

This photograph was taken aboard the *Tompkinsville* during the 50th-anniversary celebration of municipal control of the Staten Island Ferry, on October 25, 1955.

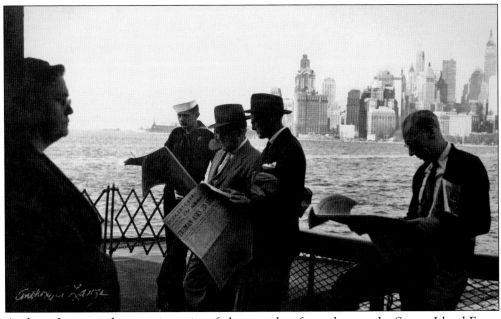

Anthony Lanza made an entire series of photographs of travelers on the Staten Island Ferry. He took this shot on September 21, 1949. It is a reminder of the importance of daily newspapers before the advent of the Internet.

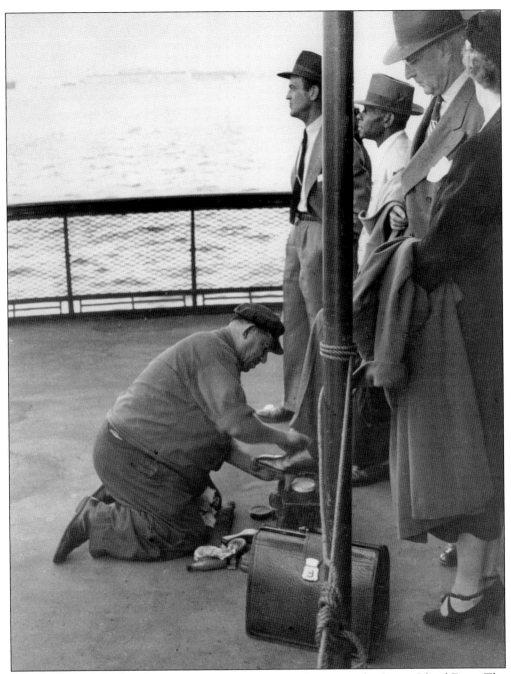

For many years, the shoeshine man was an ever-present fixture on the Staten Island Ferry. The usual tip was a nickel for women and a dime for men. The market for shining shoes dwindled as suede shoes and sneakers became popular. By 2003, the last shoeshine man bid the Staten Island Ferry good-bye. (Anthony Lanza Collection.)

Happy passengers riding the ferry on the day of the New York City Marathon are captured in these 1980s photographs. Every first Sunday in November, marathon runners begin the 26-mile route in Staten Island, where they cross the Verrazano-Narrows Bridge into Brooklyn. The route, lined with cheering spectators, goes through all five New York City boroughs.

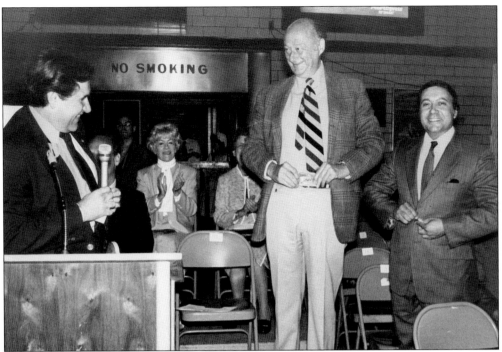

Many events were also celebrated in the ferry terminal as well as on the actual ferry. Here, Mayor Ed Koch helps with the celebration of Flag Day.

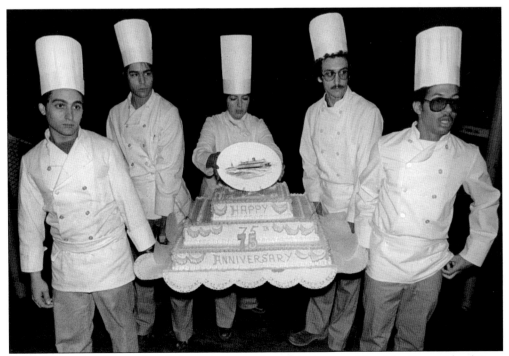

In 1980, the city celebrated its 75th anniversary of municipal ownership of the Staten Island Ferry aboard one of the system's ferryboats. This spectacular cake was a highlight of the festivities.

Photojournalist Anthony Lanza's series *Ferry Commuters* includes this c. 1970 shot taken aboard one of the Merrell-class ferryboats. Lanza photographed the reflection in one of the ferry's fish-eye mirrors, which accounts for the novel shape of the image. Passengers outside gaze at the view,

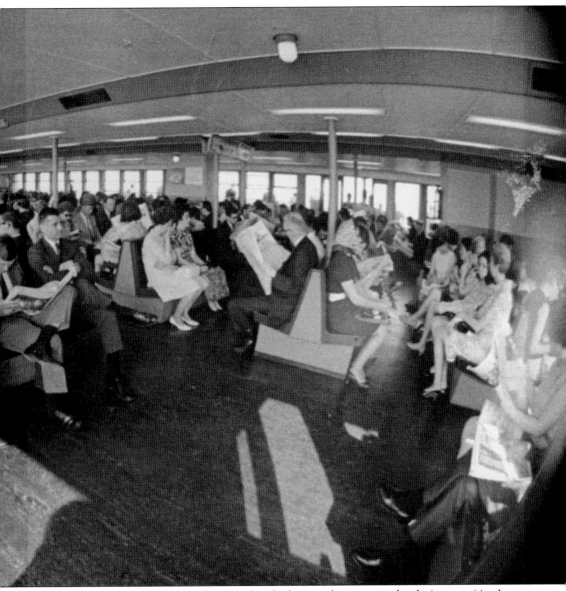

while many of those inside the cabin are absorbed in catching up on the day's news. (Anthony Lanza Collection.)

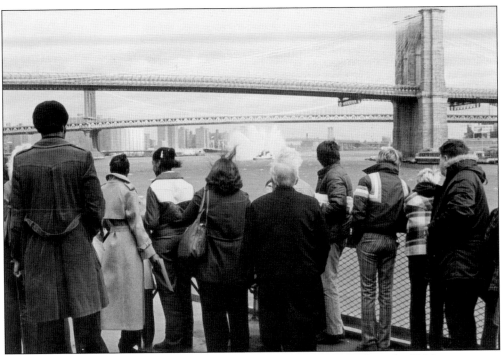

Lucky Staten Island Ferry passengers catch a glimpse of the festivities marking the 100th anniversary of the Brooklyn Bridge, on May 24, 1983.

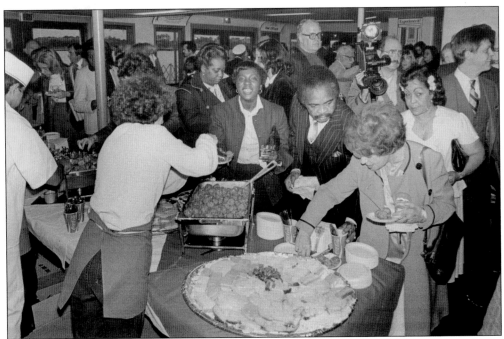

The 75th anniversary of the City of New York taking over the Staten Island Ferry is being celebrated in this 1980 photograph. It looks like it was a great party.

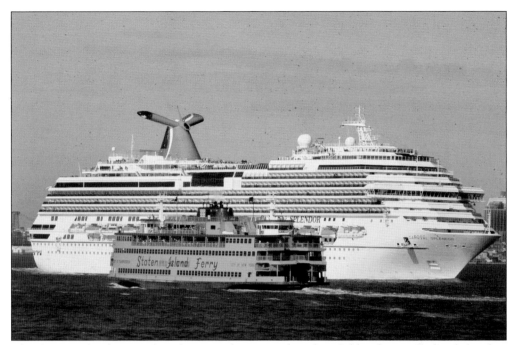

This Staten Island Ferry, though quite a large vessel, is dwarfed by the cruise ship behind it. (*Staten Island Advance*/Mario Bellumo.)

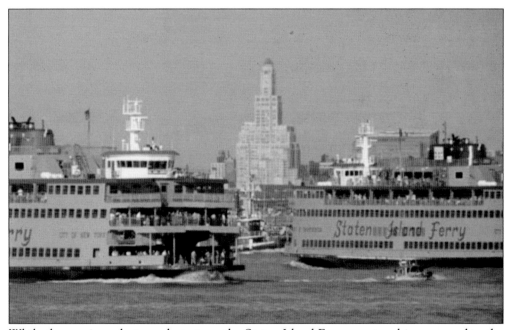

While the previous photograph portrays the Staten Island Ferry as a toy ship compared to the cruise ship, this image is the complete opposite. The US Coast Guard boat traveling alongside the Staten Island Ferry is completely dwarfed. The Coast Guard protects the Staten Island Ferry as it makes its way across the harbor each day. (*Staten Island Advance*/Bill Lyons.)

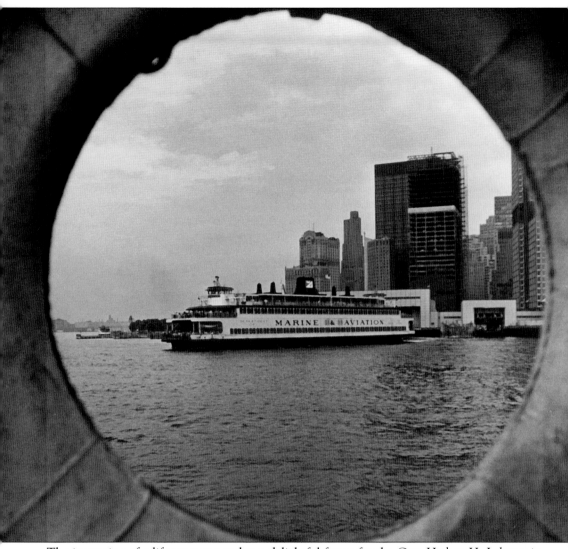

The inner ring of a life preserver makes a delightful frame for the *Gov. Herbert H. Lehman* in September 1981. The *Lehman* was then 26 years old. It was decommissioned in 2007.

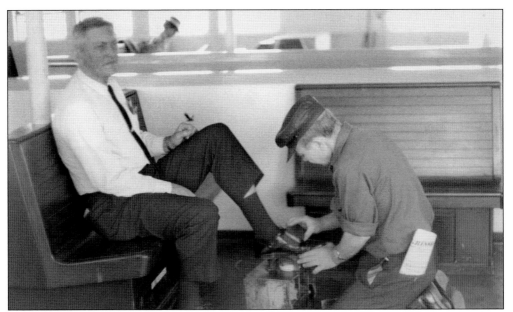

In this photograph, taken aboard the *John F. Kennedy* in July 1969, a ferry pilot is having his shoes shined. President Kennedy was assassinated in 1963, and the ferryboat named in his honor was launched two years later.

Longtime Staten Island Ferry captain Ted Costa is seen here on the *John F. Kennedy*. One of the most challenging situations for a captain is landing the ferry at Whitehall, where the vessel's bow gets hit by currents going in the opposite direction from those hitting the stern.

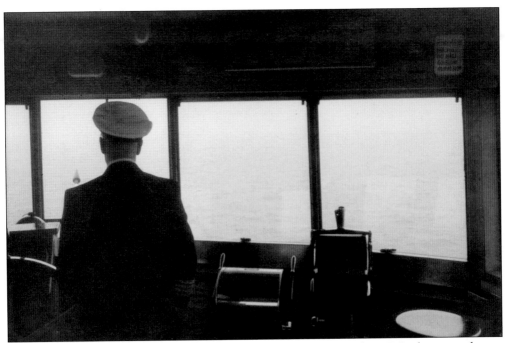

Master Robert T. Lathrop stands
at the helm of the ferryboat *Gov.
Herbert H. Lehman*, guiding the
ferry to its intended destination.
Robert J. Linden took this
photograph in December 1971.
(Robert Linden Collection.)

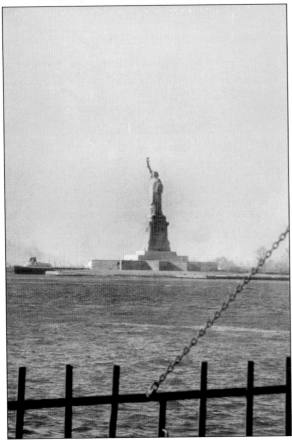

The Staten Island Ferry passes
the Statue of Liberty every time it
crosses the harbor. Thousands of
tourists take the ferry just for the
view of this universal symbol of
freedom and democracy, dedicated
in 1886. Robert Linden took this
photograph in December 1971.
(Robert Linden Collection.)

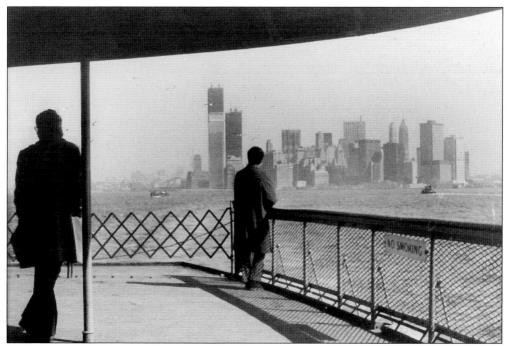

In this March 1971 photograph by Robert Linden, the twin towers of the World Trade Center are under construction. They are the two tall buildings just left of center. (Robert Linden Collection.)

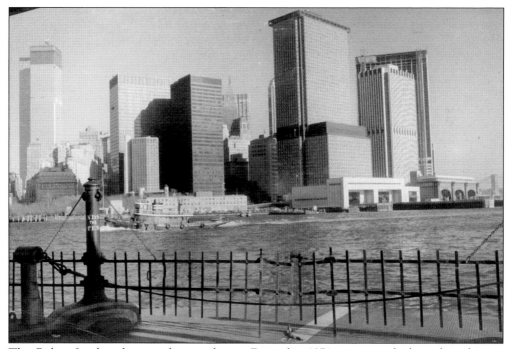

This Robert Linden photograph was taken in December 1971, nine months later than the one at the top of the page. It would be another two years before the World Trade Center (far left) officially opened on April 4, 1973. (Robert Linden Collection.)

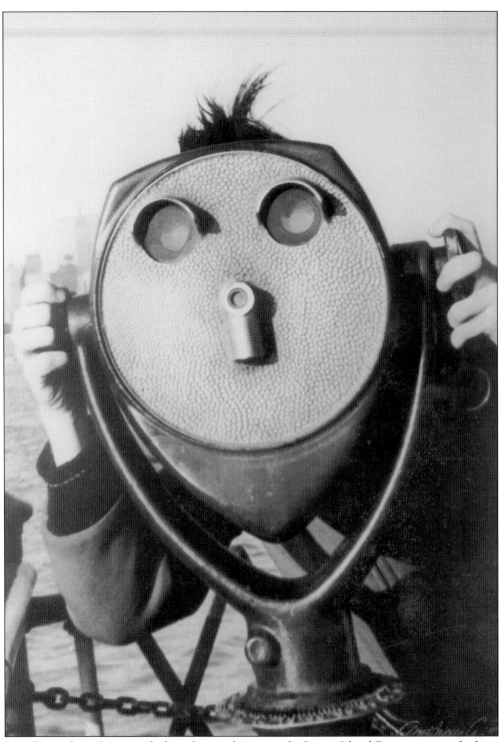

In 1959, Anthony Lanza took this whimsical picture of a Staten Island Ferry passenger looking through a viewing machine. (Anthony Lanza Collection.)

Eight

WEATHER

A consequence of global warming is that New York Harbor and the rivers feeding into it now rarely freeze. However, until the early 20th century, ice was a serious winter hazard for boats that sailed the Hudson River, the East River, and New York Bay. There are numerous accounts of vessels getting stuck in or being damaged by ice. There were times when ice floes from the Hudson River actually created "logjams" in the harbor.

Fog is extremely challenging for ferryboat captains. Fog has been the reason for many crashes throughout the history of the Staten Island Ferry. Any type of weather can greatly affect the ferryboats. Fog is usually the worst, because to not be able to see renders a captain useless. Bad weather also causes delays, and, on rare occasions, the suspension of service. No Staten Island ferryboats ran during Hurricane Sandy, which hit on October 29, 2012. Full service resumed on November 2. Technological advancements go a long way towards improving the reliability of the trip across the harbor, but weather can still occasionally gain the upper hand.

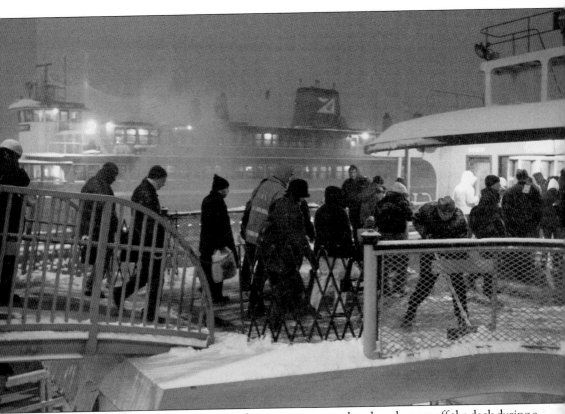

Passengers board the *Gov. Herbert H. Lehman* as a crew member shovels snow off the deck during a storm on January 22, 2004. The Staten Island Ferry is very resilient; more often than not, ferryboats will run no matter what the weather. (*Staten Island Advance*/Joel Wintermantle.)

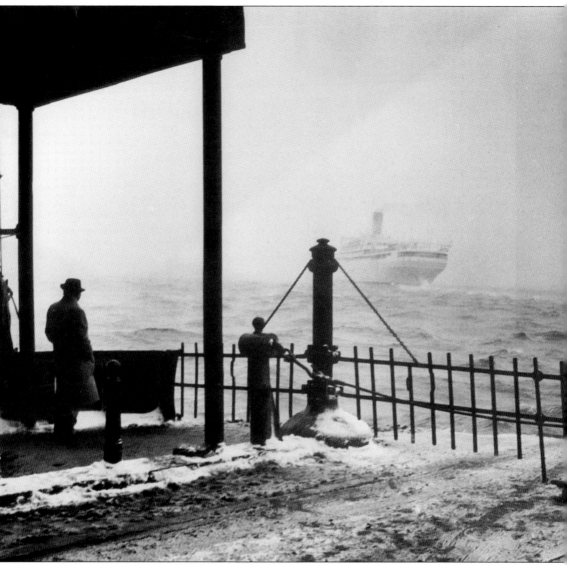

A lone passenger stands on the frozen lower deck of the Staten Island Ferry as an ocean liner passes close by. Looking at this photograph by Anthony Lanza, a person can almost feel the icy wind. (Anthony Lanza Collection.)

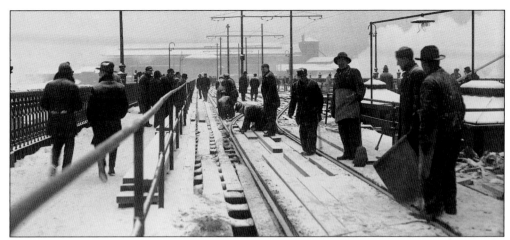

This glass plate negative shows workmen repairing planks at the St. George Viaduct in the winter of 1919. To keep the ferries running, men frequently worked through all types of weather, including snow.

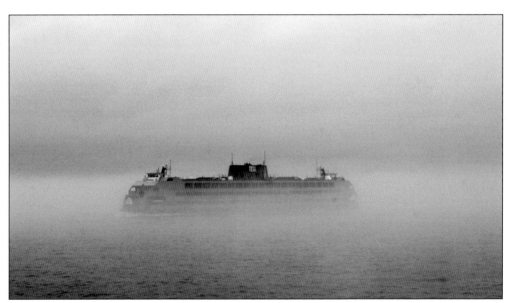

Capt. Peter Merli has recalled how he used ambient sound to "feel" his way through a fogbound harbor prior to the late 1950s, when ferries did not yet have radar. Boat traffic in New York Harbor was much heavier than it is today, adding to the risk. (*Staten Island Advance*/Jan Somma-Hammel.)

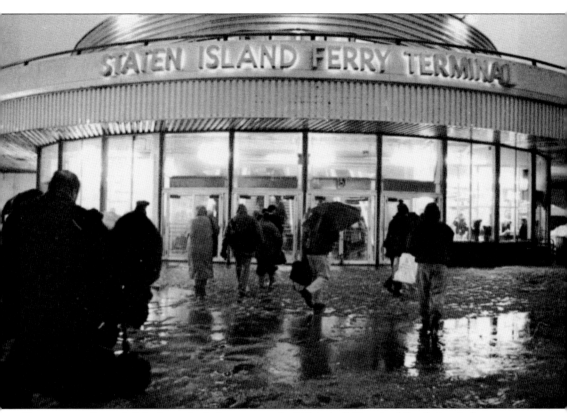

Commuters slip and slide through slush to get to the Whitehall Terminal for their trip home on the Staten Island Ferry. For the 25 minutes it takes to cross the harbor, the ferryboat will provide them with shelter from the elements. (*Staten Island Advance.*)

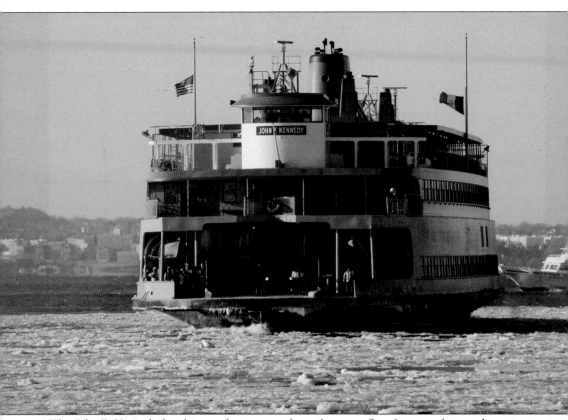

The *John F. Kennedy* ferryboat makes its way through an ice floe. Ice is no longer the common occurrence it was, owing to the rising temperatures brought on by global warming, but it can still present problems during severe winters. The ice often comes down from the Hudson River and settles in the harbor, making it difficult for the crew to navigate its way. (*Staten Island Advance/* Mike Hvozda.)

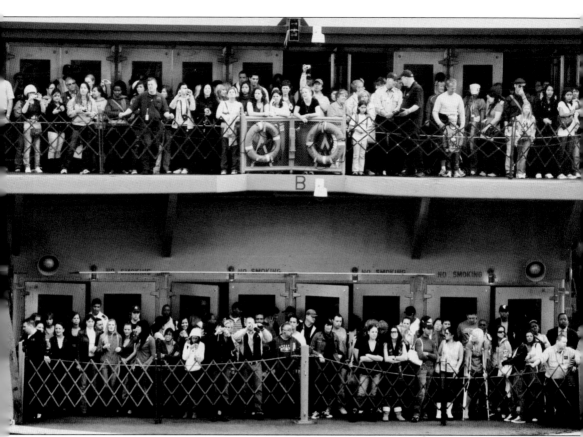

One way to beat the heat is by riding across the harbor on the Staten Island Ferry. During the summer months, the ferry is filled with tourists and New Yorkers looking for a way to stay cool. This photograph was taken on July 21, 2011. (*Staten Island Advance.*)

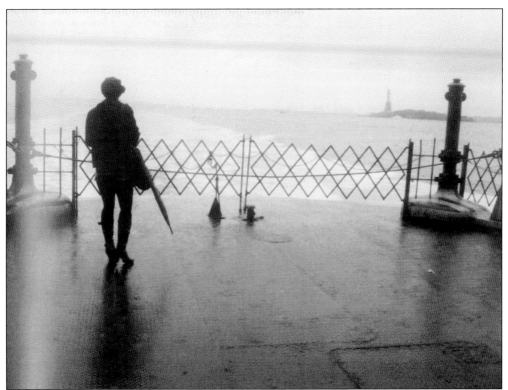

This photograph was taken the day that Hurricane Sandy hit New York. A lone passenger stands outside, watching the coming storm on October 29, 2012. The storm would go on to devastate parts of Long Island, Queens, Brooklyn, Lower Manhattan, and Staten Island. Ferry service was suspended shortly after this photograph was taken. (*Staten Island Advance*/Mario Belluomo.)

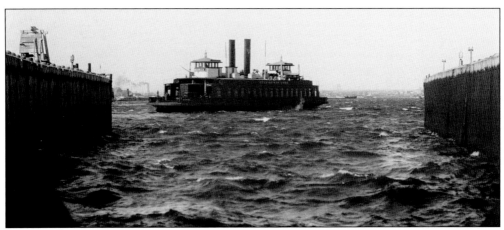

The ferryboat *Bushwick* is seen here off the slip at College Point, Queens, a ferry route to Brooklyn that ended in 1939. Rough seas are something ferries have always had to contend with. Every now and then, service will be delayed due to rough waters. (*Staten Island Advance*/Department of Transportation.)

During Hurricane Sandy, the storm surge flooded the lower level of the Manhattan terminal. It took several days to pump out the water and return Whitehall Terminal, parts of which were damaged, to service. The Staten Island Ferry had to cease operations from October 29 to November 2, 2012. It was the longest suspension in the history of the ferry. (*Staten Island Advance/ Department of Transportation.*)

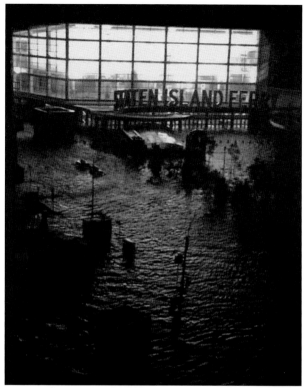

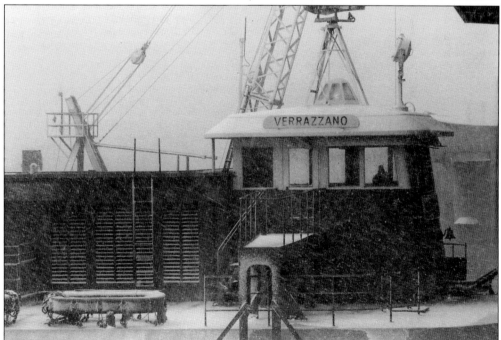

The ferryboat *Verrazzano* is seen here in December 1971, covered in a thin layer of snow. The snowflakes that blur the image give a sense of how snow limits ferry captains' visibility as they navigate across the harbor. (Robert Linden Collection.)

Discover Thousands of Local History Books Featuring Millions of Vintage Images

Arcadia Publishing, the leading local history publisher in the United States, is committed to making history accessible and meaningful through publishing books that celebrate and preserve the heritage of America's people and places.

Find more books like this at
www.arcadiapublishing.com

Search for your hometown history, your old stomping grounds, and even your favorite sports team.